Wills Guide for Canada

Tom Carter, LLB

Wills Guide
for Canada

Tom Carter, LLB

Self-Counsel Press
(a division of)
International Self-Counsel Press Ltd.
Canada USA

Self-Counsel Press acknowledges the financial support of the Government of Canada through the Book Publishing Industry Development Program (BPIDP) for our publishing activities.

Printed in Canada.

First edition: 2001

Canadian Cataloguing in Publication Data

Carter, Tom.
 Wills Guide for Canada

(Self-counsel legal series)
ISBN 1-55180-310-0

 1. Wills — Canada — Popular works. 2. Estate planning — Canada — Popular works.
I. Title. II. Series.
KE5974.Z82C37 2000 346.710'2 C00-911431-9 KE6585.C37 2000

Self-Counsel Press
(a division of)
International Self-Counsel Press Ltd.

1481 Charlotte Road 1704 N. State Street
North Vancouver, BC V7J lHl Bellingham, WA 98225
Canada USA

Contents

INTRODUCTION

1 THE ESTATE PLANNING PROCESS 1

 1. What is your estate? 3

 2. What is estate planning? 4

 3. The three types of property 5

 3.1 Joint assets with right of survivorship 5

 3.2 Designated beneficiary assets 5

 3.3 All the rest 6

 4. Three typical approaches to estate planning 6

 4.1 The government plan people 7

 4.2 The unconscious plan people 7

 4.2a The first house 8

 4.2b The first joint bank account 8

 4.2c The first job with benefits 9

 4.2d The first RRSP 9

 4.3 The conscious plan people 12

 5. Probate versus probate-free assets 13

 6. The three estate-planning documents 14

2 THE THREE-STEP ESTATE PLANNING PROCESS 15

 1. I don't need an estate plan because... 17

 1.1 "Everything is joint with my partner" 17

 1.1a It must be the right kind of joint ownership 18

 1.1b One partner dies before the other 18

 1.1c The other joint owner must also be the intended 18
 beneficiary at death

 1.2 "My uncle didn't have a will and we didn't have any problems" 19

 1.3 "Everything will be different in 30 years when I die" 22

 1.4 "If I do a will now I take away my options for later" 22

 1.5 "Doing a will means I'm ready to die — and I'm not!" 23

 1.6 "I'm too busy right now" 24

 2. The three-step estate planning process 24

 3. The "musts" and "mays" of estate planning 25

**3 PLANNING FOR DEATH: CHOOSING AN EXECUTOR
FOR YOUR WILL** 35

 1. The set-up, or Who will be my executor? 38

 1.1 What does an executor do? 38

 1.2 Who would be a good executor? 41

 2. Who gets what, when? or What must my executor do? 43

 3. The executor's tool box, or What tools does my executor 45
 need to handle the mays?

 4. The most important person in your will isn't you 47

 4.1 An individual as executor 50

 4.2 A professional person as executor 52

 4.3 A corporate executor: Trust companies 53

 4.4 Trust companies as agents for executors and trustees 55

 4.5 The public trustee 56

4 FREQUENTLY ASKED WILL QUESTIONS 57

 1. Questions about content 59

 1.1 Do I have to give something to my spouse? 59

1.2 Do I have to leave something to my children? 61

1.3 Who will look after my minor children? 62

1.4 Who will look after my minor children's money? 63

1.5 What if the whole family dies in a plane crash? 64

1.6 What if I re-marry? 65

2. Questions about form 66

2.1 Can I change my mind? 66

2.2 How is a will executed? 67

2.3 Can my family be witnesses? 67

2.4 Does a will have to be typed? 67

2.5 Can I do a will on videotape? 68

2.6 Where should I store my will? 68

2.7 When should I review my will? 69

2.8 What happens to my debts? 69

2.9 What if I move? 70

2.10 What if I want to donate my organs? 70

2.11 How do I give a specific bequest? 70

2.12 Burial instructions 71

2.13 How can I revoke my will? 71

2.14 Can my will be voided? 71

3. What can my executor do while I'm still alive? 71

5 ESTATE PLANNING FOR LIFE: THE LAW OF AGING 87

6 YOUR ENDURING POWER OF ATTORNEY 97

1. What is a power of attorney? 99

2. What is an enduring power of attorney? 99

3. What are the "maybes" that an attorney must deal with? 101

4. The set-up, or Who will be my attorney? 103

5. The trigger, or When do I want my attorney to start? 106

6. The attorney's tool box, or What does my attorney need in order to do the best job? 107

7.	The challenge of long-term asset management	108
8.	The challenge of working with your health care agent	109

7 YOUR ADVANCE HEALTH CARE DIRECTIVE — 119

1.	The set-up, or Who will be my agent?	123
2.	The trigger, or When do I want my agent to start?	125
3.	End-of-life instructions, or What do I want my agent to do if I am terminally ill?	126
4.	The agent's tool box, or What does my agent need in order to do the best job?	127
5.	The most important person in your health care directive is your agent	129

8 THE COST OF DYING: PROBATE FEES AND INCOME TAX — 141

1.	Probate fees: "I don't want my family to pay them"	143
	1.1 What is probate?	143
	1.2 Fees associated with probate	145
	1.2a Probate tax	145
	1.2b Legal fees	146
	1.2c Executor's fees	146
	1.2d Other common estate administration costs	149
	1.3 Avoiding probate	150
2.	Income tax and death	150
	2.1 Income earned by you to date of death	150
	2.2 Income earned by your estate after death	150
	2.3 Capital gains tax at death	151
	2.4 Clearance certificate	152

9 FINDING AND USING A GOOD ESTATE-PLANNING LAWYER — 155

1.	The risks of doing it yourself	157
2.	Advantages of using a lawyer	158
	2.1 The "proof you had your marbles" factor	158

2.2 The "complete advice" factor 158

2.3 The "multi-generational thinking" factor 158

2.4 The "who pays if I make a mistake?" factor 159

2.5 The "loss leader" factor 159

2.6 The "legal boiler plate" factor 159

2.7 The "personal comfort" factor 159

2.8 The "future estate work" factor 160

3. All lawyers are not created equal 160

4. Three steps to finding a good estate-planning lawyer 160

4.1 Step 1: Get the names of five good lawyers 161

4.2 Step 2: Use the phone 162

4.3 Step 3: Visit the prospects 164

10 GETTING STARTED 167

APPENDIXES

1 Contact information for the public trustee 171

2 Three-step estate planner 177

GLOSSARY 195

SAMPLES

1 Dealing with the "mays" 48

2 Will 75

3 Enduring power of attorney 113

4 Advance health care directive 133

TABLES

1 Summary of intestate succession laws 20

2 Names of intestate succession laws by province 21

3 The logical structure of a will 38

4 Dependant relief laws 60

5 Enduring power of attorney laws and terms by province 90

6 Advance health care directive laws and terms by province 91

7 The logical structure of an enduring power of attorney 104

8 The logical structure of an advance health care directive 124

9 Probate courts and laws by province 144

10 Probate tax rates by province 147

WORKSHEETS

1 Three-step estate planner: Step 1 27

2 Three-step estate planner: Step 2 72

3 Three-step estate planner: Step 3 111

4 Three-step estate planner: Step 3 continued 130

Notice

Laws are constantly changing. Every effort is made to keep this publication as current as possible. However, the author, the publisher, and the vendor of this book make no representation or warranties about the outcome or the use to which the information in this book is put and are not assuming any liability for any claims, losses, or damages arising out of the use of this book. The reader should not rely on the author or the publisher of this book for any professional advice. Please be sure that you have the most recent edition.

Note: The information contained in this book does not apply to the province of Quebec. Readers in Quebec may wish to consult *Le testament au Québec,* also published by Self-Counsel Press.

Introduction

Of course you can plan your estate!

"How can I plan my estate? I can't even get a will done, for heaven's sake!" Sound familiar? It should. Canadians may be creative, energetic, resourceful, and oh-so-polite, but one thing we are not is a nation that plans for aging and death. In fact, some sources estimate that as many as 40 percent of Canadians between the ages of 40 and 59 do not have wills.

For almost 20 years I had my own law practice, and for the last ten of those years I specialized in the law of aging — that's what I call the legal issues arising from the inevitable human realities of aging and death. Like many lawyers, I looked for clients by giving countless free seminars on wills, enduring powers of attorney, adult guardianship and trusteeship orders, and living wills. The result was always the same. Folks always came out to hear what I had to say (and they always appreciated the free coffee and donuts), but for every 20 people who attended a seminar, only one or two would make an appointment for my services.

Things didn't improve much when I put my will package on the table at a school-sponsored silent auction or even when I gave it away as a door prize. Only about half the winners ever called to make an appointment.

Fortunately, not all my efforts to encourage people to plan their estates met with such limited response. I did have a 100 percent sign-up success when I participated in a low-cost will program for the Society for the Retired and Semi-Retired in Edmonton. "Hah, no surprise," you say. "Older folks are more likely to be serious about estates and wills than are younger people, especially if the price is low." Perhaps. And as long as there was a staff member who oversaw the program and a team of dedicated volunteers who phoned people to make sure they kept their appointments, people came in and wills got done. But funding cutbacks in the 1990s resulted in the loss of that staff member, and when those wonderful volunteers moved on to other projects and those reminder calls stopped, people stopped showing up for appointments and the program died.

So it seems that many Canadians can't be moved to plan their estates, in spite of the best efforts of the legion of lawyers who inhabit every office tower, shopping mall, and street corner today, and regardless of the information available to us in the media.

But what about the people who do plan their estates? Who are the intrepid souls who get this difficult job done? One group of lukewarm estate planners well-known to lawyers everywhere are those lucky people who are leaving next week on an extended vacation. They phone, usually late on a Friday afternoon, to say that they are going to Mexico/Arizona/Hawaii for three months next Thursday morning and could they come in on Tuesday at 5:30 p.m. to sign simple wills? No discussion, no information, no nothing. Sigh. They may be will makers, but they are not estate planners, and they can be very difficult to work with because they see this job in such simple terms.

Another group we frequently see are those who leave everything to the last minute — often the very last minute. Diagnosed with a fatal illness, they call from their hospital bed wanting to make a will. Everyone's heart goes out to them and most lawyers do their best to help them.

There is, however, another group: rare perhaps, but wonderful to work with. They are those organized, thoughtful people

who realize that a good estate plan is one of the most valuable, and least expensive, gifts they can give to their loved ones.

These people know that:

- Every Canadian already has an estate plan — the default plan of the law of their province — but they would rather make their own.

- An estate plan is more than a will — it can include assets that pass to others outside of the will.

- An estate plan is not just for death — they might need an enduring power of attorney and a health care agent while they are still alive.

- An estate plan doesn't hasten death.

- An estate plan does not limit their freedom to deal with their assets during their lifetime.

- An estate plan isn't written in stone — it can be re-done any time — and should be re-evaluated whenever they experience a life-changing event.

Who are these estate planners? They are people just like you:

- Young parents who want to do the right thing for their children if one or both parents should die unexpectedly

- Single parents, by choice or by chance (after divorce)

- Common-law couples

- Same-sex couples

- Those who re-marry later in life and struggle to balance their desire to benefit the children from their first marriage with the wish to make adequate provision for their new spouse

- Single people who don't have financial dependants but who want to ensure that after they are gone, their assets do the most good for the people or causes of their choosing

None of these estate planners are possessed of a special gene or a superhuman IQ. They are people like you and me. So what's the difference? What gets them motivated to tackle the tough job of thinking through an estate plan and getting their thoughts on paper in a coherent and legal form?

Just this: they take the time to become knowledgeable about estate planning, they are concerned to leave a legacy of their own choosing, they get organized, and they don't put it off. I would like to help you become one of those knowledgeable, motivated, organized people who gets the job done. I would like to help you become an estate planner.

After reading and understanding this book and organizing yourself, most of you will be able to make your own estate plan in much less time than you think. Then you will be ready to get all the necessary documents done, whether you decide to do it yourself or hire a lawyer to help you.

If you choose to go to a lawyer, you will understand the pros and the cons of working with him or her. You will know how to pick a thoughtful, knowledgeable will and estate planning lawyer to work with you, and you will be able to tell if that lawyer is creating documents that are right for your needs.

Finally, you will know what important life events should remind you to review your estate plan, and what you need to look for when you do that review.

I want to help you take control, make the basic estate planning choices that everyone should make, and get all the relevant estate planning documents done. Then you will enjoy the peace of mind that comes from getting things in order.

If this sounds good to you, read on.

Of *course* you can plan your estate. It is easier than you think. You will be glad you did, and your loved ones will thank you.

1

The Estate
Planning Process

1. What Is Your Estate?

Your estate is everything owned by you, and everything that is owed to you by someone else.

Think of what you own — not just your house, car, furniture, bank accounts, savings bonds, mutual funds, life insurance, and other assets of obvious financial significance, but also items of emotional importance such as Grandpa's war medals or Grandma's family Bible, and even your clothes, pots and pans, linens, and other household goods. All of it has value, and all of it has to find a new home after you die.

This may seem obvious, but I didn't understand the practical importance of it until I left my law practice and began working as a trust officer. One of my first assignments was to go into the apartment of an elderly client who had died and decide what was to be done with the contents. I looked around the living room at what was the largest collection of plastic plants and flowers I had ever seen. I saw no dollar value in it, and decided it should be thrown out.

However, the auctioneer who had come to sell the furniture and other items saw it differently. "Don't throw them out," he

said. "We'll put them in a box and someone will buy them." I was skeptical, but sure enough, when he came back after the auction with the cheque for the estate, there was an item on the statement showing that the plastic flowers had been bought and paid for. So, even though you look around you at a house full of used furniture, don't assume that it won't be of value to someone. And all of it has to be dealt with after you are gone.

2. What Is Estate-Planning?

Estate planning involves setting up a practical plan for the management and distribution of your assets after your death. It also involves choosing the right person as your executor to make sure the plan gets carried out. Good estate planning includes taking all reasonable steps to avoid probate after death by using all available probate-free assets to pass assets to loved ones. (Probate-free assets are discussed later in this chapter.) As they plan, some people discover they need to put assets into a trust, either during their lifetime or, after they die, through their will, to preserve wealth or to assist and protect disadvantaged family members. And finally, but very important, good estate planning involves reviewing that plan at reasonable intervals to make sure it still does what it was originally designed to do.

> Estate planning involves setting up a practical plan for the management and distribution of your assets after your death.

There is, however, a less well-known and equally important part of estate planning that has came into focus only in recent years. It is summed up in the question, "Who will manage your assets and your personal care if you become incapable of doing that while you are still alive?"

In the 1990s most provinces passed laws allowing people to appoint someone to make those decisions in the event of incapacity through documents typically known as powers of attorney and advance health care directives. Lawyers now regularly discuss this as part of the will making and estate planning process. I discuss these estate planning decisions in Chapters 6 and 7.

3. The Three Types of Property

Different types of property are treated differently upon death. If you understand how your property will be considered and treated upon your death, you are better able to make estate planning decisions that will be of benefit to your estate.

3.1 Joint assets with right of survivorship

Owning property jointly with right of survivorship (often called joint tenancy when referring to ownership of a house) means that each of the buyers simultaneously owns all of the asset. So when one joint owner dies, the surviving owner already owns the entire asset, no matter what the deceased owner's will says.

Many couples put their house and bank account in joint ownership for a variety of valid reasons that are not related to estate planning. Other assets that people commonly put in joint names are term deposits, guaranteed investment certificates, and Canada Savings Bonds.

It isn't only couples who jointly own assets. As a matter of convenience, an aging parent may decide to put a child on a bank account or even on title to the parent's home. If the child is given the kind of joint ownership that includes the right of survivorship, then, when the parent dies, ownership of the entire asset automatically goes to the child. A conscious estate planner knows this, and can make other arrangements if this isn't what he or she wants to happen. An unconscious planner doesn't know this, and takes the risk that what happens after death may not be to his or her liking.

3.2 Designated beneficiary assets

Designated beneficiary assets are assets such as RRSPs, RRIFs, LIRAs, employer pensions, and life insurance that automatically pass to a nominated survivor at your death regardless of what you say in your will. That is because, when you buy the asset, the law allows you to choose the person you want to receive it when

If you understand how your property will be considered and treated upon your death, you are better able to make estate planning decisions that will be of benefit to your estate.

you die. You do that simply by completing the relevant section on the asset's application form and signing it. This is called designating a beneficiary, and the person you name in the space on the form is called a designated beneficiary.

3.3 All the rest

This category covers all the other assets that are in your name only. You may own a car in your own name (but cars depreciate over the years and are never worth what we think they are). You may have won a lottery or inherited money from a parent. You may have an employment bonus or termination settlement. Often, these assets are put in sole names and are invested without a thought given to the estate planning consequences.

Tenancy in common means that each of the buyers owns a portion of the title (usually half, although they can agree otherwise).

You may have decided to purchase an asset with someone else as a tenant in common (as opposed to joint tenancy with right of survivorship). Tenancy in common means that each of the buyers owns a portion of the title (usually half, although they can agree otherwise). From an estate planning point of view, the important thing to realize is that when your fellow joint owner dies, his or her share does not automatically belong to you. In fact it goes to his or her heirs, which means you now have new partners sharing ownership of the asset.

4. Three Typical Approaches to Estate Planning

Now that we have a working definition of what your estate is, what estate planning is about, and of the types of property you could own, let's look at the typical ways people approach estate planning in order to understand what a comprehensive approach involves.

People typically adopt one of three different approaches to planning their estates — from those who know nothing and care less, to those who make unknowing decisions in the context of acquiring assets as they go, to those who know what they are

doing and plan accordingly. As we take a look at each one now, try to determine which category you belong to. The good news is that by the end of this book you will belong to the last category, and all you will have to do is get your documents done.

4.1 The government plan people

The government plan people are the people who make it all the way to the end of their lives without actively doing anything about planning their estates. This is a large number of people; think of that 40 percent of people between the ages of 40 and 59 who don't have wills.

But it is not true to say that these people die without any estate plan at all. Every province has a backup system. It's as if the government has already written a will that automatically applies to each one of us unless we overrule it by making our own. This government will is found in the intestate succession law of each province.

Many people assume that this government will gives everything to the government, but that is not true. If you have a spouse, children, or next of kin of almost any description, they are the recipients, or beneficiaries, of your estate. But if you don't have any relatives at all, which means your estate has nowhere to go, most of those laws do eventually give it to the government. It's as if the government is your beneficiary of last resort. See Chapter 2 for more information on intestate succession.

4.2 The unconscious plan people

A significant number of people make hugely significant estate-planning decisions every day without knowing it.

"Wait a minute!" I hear you say. "How could anyone make a decision as important as where a valuable asset is to go after death without knowing it?" Well, it's because there is a hidden estate-planning component in many of the important things people normally do, such as buying a house, starting a job, or opening an RRSP. Unfortunately, these estate-planning choices-in-disguise

> Every province has a backup system. It's as if the government has already written a will that automatically applies to each one of us unless we overrule it by making our own.

usually get overlooked in the excitement and pressures of the moment. Take this young married couple as an example.

4.2a The first house

A young couple buying their first house will be preoccupied with immediate, practical matters like raising the down payment, getting the mortgage, booking the movers, and buying appliances. In the confusion, they visit the lawyer to sign a pile of papers as big as the City of Red Deer phone book.

One of the questions the lawyer is sure to ask is, "How do you want to be described on the title?" This might as well be a foreign language to most people, and the lawyers know it, so they continue with a very quick explanation of the differences between tenancy in common and joint tenancy with right of survivorship.

> By choosing joint tenancy, the couple ensures that if one of them dies, the other will automatically get full ownership of the house.

This is obviously a pretty important difference. By choosing joint tenancy, the couple ensures that if one of them dies, the other will automatically get full ownership of the house. That would have huge significance if tragedy struck unexpectedly. If they had chosen tenancy in common, the surviving spouse would get ownership of the deceased's half of the family home only if the deceased left a will saying so. Instead of a quick, probate-free transfer of ownership, however, he or she must now probate that will before anything can happen. If the deceased did not leave a will, the survivor is at the mercy of the government default will of his or her province. That may or may not guarantee transfer of the deceased's share of the house to the survivor, and the survivor would be faced with legal proceedings and a court order to sort it out. So, depending on the ownership choices they made, this couple already has an unconscious estate plan, at least in respect to their house — which for many people is the most significant asset they own.

4.2b The first joint bank account

Imagine the innocent enthusiasm of our young couple as they enter the bank to open their first joint account. Hand in hand,

they stare dreamily into each other's eyes while the bank employee runs through the drill of opening a joint bank account at the speed of a cable modem.

Once again, documents had to be signed, and once again a hidden estate-planning decision was waiting to be made. One of the documents said that the account would be joint with right of survivorship, and our happy couple nodded and signed it. Fortunately, once again, joint with right of survivorship is exactly what most couples would choose, for the same reasons we discussed with respect to the house.

4.2c The first job with benefits

Then both members of our couple get their first big jobs, the kind that provide real benefits. They must meet with their employers' human resources officers to sign more papers. Each job has the benefit of a group life insurance policy, and among the papers is a beneficiary designation form for group life insurance.

The young couple doesn't know much about insurance, but this benefit comes with each job. The human resource officers tell each of them that most married people name their spouse as beneficiary. Since this makes sense, they agree, fill in the space on the form, and sign it. If one of them should suddenly die, the insurance company would pay the proceeds directly to the survivor. Again, a sensible choice, but an estate planning decision made in a vacuum.

4.2d The first RRSP

After several years of working and paying income tax, our couple notices all the ads that appear early in the year promoting registered retirement savings plans (RRSPs). In particular, the two like the part about using RRSPs to reduce taxes. They make an appointment to see their banker to get more information, and after a lengthy conversation about contribution limits, pension adjustments, tax-free compounding, and tax reduction, they each buy one. Once again, paper has to be signed, and once again a hidden estate-planning decision is lurking.

The bank officer draws their attention to the space at the bottom of the application form labelled "beneficiary." Our couple is becoming experienced by now, and after a brief discussion they designate each other, and head home to calculate the amount of their tax refunds. Of course, if one of them should suddenly die, the principal and interest in the deceased's RRSP would pass to the survivor and be deposited directly into his or her RRSP.

It's hard to argue with these results, and I don't have a problem with them. In Chapter 4, we will talk about the consequences of not re-visiting these designations if you experience some common changes in your life, such as divorce and re-marriage. For now, I simply wish to point out the hidden estate-planning decisions that ordinary people make as they go about their normal daily lives, and the power of these seemingly innocent choices if tragedy strikes.

Of course, single people also face these situations and struggle with the same choices. Unlike young married couples who usually operate on the assumption that "all goes to spouse," single people have different estate planning needs. Let's look at three possibilities:

Example 1: Mark

Mark is a single person who has the equivalent of a spouse; that is, a significant life partner to whom all of his estate is intended to go. Mark may choose to do what our married couple did:

- Put his partner on the title to the house as joint owner with right of survivorship.
- Open a joint with right of survivorship bank account with his partner.
- Designate his partner as beneficiary of his employment pension plans and benefits.
- Designate his partner as beneficiary of an RRSP.

Unlike young married couples who usually operate on the assumption that "all goes to spouse," single people have different estate planning needs.

Example 2: Denise

Denise is a single person without a partner. She could do the following:

- Take the title to the house in her own name.
- Open a bank account in her own name.
- Designate a specific person (e.g., parent or sibling) as the beneficiary of any employment life insurance benefits.
- Designate "my estate" as beneficiary of an RRSP.

In this case, the house and bank account would form part of her estate and would have to be probated before they could be distributed to Denise's beneficiaries named in the will.

Example 3: Ken

Ken is a single person with a significant partner. However, he also wishes to leave assets to family members. Ken might do the following:

- Take the title to the house jointly with his partner.
- Open one bank account in his own name for his own use, and another jointly with right of survivorship with his partner for mutual expenses.
- Designate "my estate" as beneficiary of any employment life insurance benefits.
- Designate a specific person (e.g., parent or sibling) as beneficiary of an RRSP.

In every case, our single person did what was needed to get these transactions out of the way so he or she could get on with life, but he or she isn't off the estate planning hook yet. In good estate planning, there is always another question to be asked.

Mark must now ask the question, "What happens if my partner dies before me? Then where do I want my assets to go?"

Denise and Ken have two more questions to ask: "What happens if the person I have named in my RRSP or life insurance policy dies before me?" and, "Who gets my estate?"

Let's look again at the choice made by Ken concerning the house. You know that there are two types of joint ownership for houses, and Ken hasn't indicated which one he has in mind. The question is, "What happens to his share of the house when he dies? Does it go to Ken's partner or to Ken's family?"

We see that, unlike married couples, a single person cannot shrug off his or her estate planning responsibilities by saying "all goes to spouse." He or she is just as likely to make important estate planning choices in the dark as is a married person. We all, therefore, have to be careful about giving thought to what we intend in even the simplest situations that have a hidden estate-planning component.

This type of hidden estate planning also happens with other important assets, and it is obviously different from sitting down and thinking through an estate planning strategy. But, because it is legal and binding, it deserves to be fully and properly understood. And when people understand it, they move to the third category of estate planners and become conscious planners.

4.3 The conscious plan people

The conscious plan people are the people who understand what is in their estate and what estate planning is all about. They don't make estate planning decisions unconsciously, nor do they make piecemeal decisions as assets come along. They understand the three types of property and the value of each of the three estate-planning documents (see below). They look at the global picture, and they plan for life as well as death. You are now well on your way to becoming one of these conscious planners.

The conscious plan people are the people who understand what is in their estate and what estate planning is all about.

5. Probate versus Probate-Free Assets

Joint assets with right of survivorship and designated beneficiary assets are assets that are owned in such a way that they automatically pass to someone when you die. Obviously, these assets will pass on no matter what your will says. They will even pass on to appropriate people if you do not have a will. Because they don't involve your will, we say that they are "probate free."

But what about the rest of your assets, the ones in your name only that can't be designated? Like it or not, those can only pass according to the terms of your will, or, if you don't have one, according to the government default will in your province. And before that can happen, your will must be probated by a judge.

We will talk more about the probate process in Chapter 8, but for now, it's important to realize that your property consists of either probate-free assets or probate assets.

Probate-free assets:

- joint with right of survivorship assets
- designated beneficiary assets

Probate assets

- assets in your name only (or "all the rest")

"So," I hear you thinking, "if our couple owns everything jointly, or if each has designated the other as beneficiary of his or her designated assets, why do they need a will, let alone a full-blown estate plan?" That's a good question. The way things stand now, if one dies, the other takes all. But what if they both die together? Who takes their estates? Parents? Brothers and sisters? His, hers, whose?

And what if they have children? Most people would say that all should go to the children. But when? Who will manage it in the meantime? On what terms? And who will raise the children? And what if one of the children dies before reaching the specified age?

A complete estate plan
is more than a will.

Chances are, both members of our couple are careful people who don't want to leave all these important issues dangling. But these "what if" questions show why owning probate-free assets is not enough. Our couple needs a multi-generational estate plan that suits the specific needs of themselves and their family, and provides for management and control both before and after death. As we saw earlier in this chapter, single people may not have spouses or children to worry about, but they all have friends, relatives, and favourite causes they wish to benefit after they die. And they, too, need to make arrangements for management of their estates and personal care if disability strikes while they are alive. This underlines the importance of the three estate-planning documents.

6. The Three Estate-Planning Documents

Estate planning after
death doesn't mean
that you will somehow
be able to magically
direct events after you
are dead.

A complete estate plan is more than a will. In fact, three different documents are required: the will, the enduring power of attorney, and the advance health care directive.

The enduring power of attorney and advance health care directive may come into effect while you are still alive, but the will only comes into effect once you die.

Estate planning before death means making arrangements for someone to take over the management of your assets and financial affairs, and to make medical and personal care decisions for you in case you lose your ability to do these things yourself due to illness or an accident. We will look at these documents in more detail in Chapters 6 and 7.

Estate planning after death doesn't mean that you will somehow be able to magically direct events after you are dead. Nor does it mean that you do nothing while you are alive and leave it all to someone else to sort out after you are gone. It means arranging and planning as much as you can now, using all the probate-free assets that make sense in your situation, and doing a thorough will to take care of all the rest.

2

The Three-Step Estate Planning Process

M any people think that doing an estate plan is only about doing a will. As I said in the introduction, it's not, but since doing a will — or avoiding doing a will — is the starting point for most people, let's begin our discussion of the importance of estate planning with a review of some of the most common reasons people give for not having a will. Does any of this sound familiar?

1. I Don't Need an Estate Plan Because...

1.1 "Everything is joint with my partner"

This is a very common (and usually good) reason for not doing a will, especially for married folks, but also for single people who jointly own assets with right of survivorship with a partner or friend. If everything you own is in the right kind of joint ownership, and if only one owner dies, then everything will automatically go to the survivor. But there are three very important conditions here. Joint ownership only works as a substitute for a will under certain circumstances.

1.1a It must be the right kind of joint ownership

As we discussed in Chapter 1, there are two very different kinds of joint ownership, and the difference is critical when one of the joint owners dies. If you own everything with your partner in joint ownership with right of survivorship, then your assets will be transferred to your partner upon your death, and an estate plan is not necessary.

1.1b One partner dies before the other

Common sense tells us that it is unusual for two people to die at the same time. In the ordinary course of events, couples and non-married joint owners live to a ripe old age together. But eventually, inevitably, one of them dies, leaving the other alone. You probably know many widows or widowers for whom a will wasn't an issue because everything was jointly owned with right of survivorship, and therefore ownership automatically passed to the survivor.

But we all know that the unlikely can happen. Both partners can die together under not-too-unusual circumstances. Let's say they fly to a sun spot for a holiday, having left the children with Aunt Mary, and the plane goes down. They owned everything together, and didn't do a will. Now what?

1.1c The other joint owner must also be the intended beneficiary at death

Things get even more complicated when the joint ownership is between two people, but one does not intend for the other to get whole ownership of the asset at death, such as an aging parent and one of many children. Let's say Dad dies and Mom decides to put one of the children on her bank account so the child can have access to the money if Mom should ever be unable to look after the banking herself.

The two of them go to the bank and they sign a little card with lots of fine print on the back that they never read, and the bank puts the child's name on the account. It's a simple way of making sure Mom will be looked after, and it is very common. But

Things get even more complicated when the joint ownership is between two people, but one does not intend for the other to get whole ownership of the asset at death.

from a legal point of view, an important change of ownership has just occurred, and, in the wrong hands, that can lead to serious problems.

The fine print on the back of the card almost always says that the account is now "Joint with Right of Survivorship." Sometimes the acronyms JWROS or JROS are used. When Mom dies, the law presumes that the survivor takes all, which very often is not what Mom intended. She may have wanted all the children to share that money equally, and she may even have put that in her will. But if the joint child exercises his or her right of survivorship over that account, none of the other children will get a penny of it.

And there is another risk. Before Mom dies, the joint child can take money out at any time without Mom's permission or knowledge. If the child is dishonest, or decides that Mom really intended to pay him or her for all the extra work he or she is doing looking after Mom while the brothers and sisters go about their busy lives, there may not be much left to share with the others when Mom dies.

So these joint accounts can present legal problems based on the transfer of ownership that takes place as soon as the card is signed.

Joint accounts can present legal problems based on the transfer of ownership that takes place as soon as the card is signed.

1.2 "My uncle didn't have a will and we didn't have any problems"

If your uncle didn't have a will, all this means is that he chose to leave his assets to his next of kin in the order, and amounts, set out in the will the government wrote for him. In Canada, each province makes its own laws on matters of property and civil rights, which includes wills and estates. Even though the details are different from one province to the next there is a general pattern, which is summarized in Table 1. The following order is usually followed:

- husband or wife
- children

- grandchildren
- great-grandchildren
- parents
- brothers or sisters

As always, please consult the law of your province for specific information (see Table 2).

TABLE 1
SUMMARY OF INTESTATE SUCCESSION LAWS

If you die without a will and you have:	Your assets will go to:
A spouse only	That spouse
Children but no spouse	Those children equally
A spouse and children	Your spouse (who gets a defined amount) and the remainder is divided among the spouse and children as the provincial law directs
	Exceptions: In PEI and Newfoundland, assets are split equally among your spouse and children
	In Manitoba, all goes to your spouse
No spouse or children	Your closest living next of kin starting with your parents;
	if neither are alive, then your brothers and sisters or their children;
	if none of them are alive, then any other next of kin;
	if none of them are alive, then the provincial government

TABLE 2
NAMES OF INTESTATE SUCCESSION LAWS
BY PROVINCE

British Columbia	Estate Administration Act
Alberta	Intestate Succession Act
Saskatchewan	Intestate Succession Act
Manitoba	Intestate Succession Act
Ontario	Succession Law Reform Act
New Brunswick	Devolution of Estates Act
Nova Scotia	Intestate Succession Act
Prince Edward Island	Probate Act
Newfoundland	Intestate Succession Act
Northwest Territories and Nunavut	Intestate Succession Act
Yukon	Intestate Succession Act

Let's look at some common results of your uncle's decision not to make his own will:

- Your uncle wasn't fussy about choosing an executor to take charge of and distribute his assets, so he left that choice up to the government default will. It has a list of relatives and others who have the right to ask a judge to give them this job.

- He wasn't concerned about setting aside any money for his favourite nephews and nieces. The government will gives it to his brothers and sisters; the nephews and nieces get something only if their parent happened to die before your uncle.

- Your uncle didn't care to pick his own trustee, so, if the nephews and nieces do get something, the government rules say their money is handled by the public trustee until they reach the age of majority (see Chapter 3 for more information about the public trustee).

- He didn't expand the opportunities for investing and spending the nephews' and nieces' money while it is in trust, so the public trustee's officials will follow whatever investment and spending rules their government permits.

These are some of the biggest, most common problems that can arise when someone dies without a will. For those of you who really did have such an uncle, and who did not have any problems with his estate, be glad. But that doesn't necessarily mean that your own affairs will be settled as easily. The most important point to remember is that you can eliminate the uncertainty and make your own choices in your will. When you think about it, most people would rather do that than leave everything up to the government to decide after they are gone.


The most important point to remember is that you can eliminate the uncertainty and make your own choices in your will.


1.3 "Everything will be different in 30 years when I die"

This is another excellent point — which also overlooks the obvious. How can you be sure you are going to live for another 30 years? Isn't it a good idea to accept the possibility that something unexpected could happen before then? When most people think about it, they admit that this excuse doesn't stand up, because they know it is better to leave their loved ones with a plan — no matter how unlikely it is that they will need it — than no plan at all.

1.4 "If I do a will now I take away my options for later"

This objection comes in two variations:

- Many people believe that a will is forever: if they sign a will today, they give up their right to make changes to it tomorrow.

- Some people also believe that making a will sets everything in concrete and that they have to leave all their assets as is for the will to work.

Fortunately, neither is true in the vast majority of cases. If they were, no one would ever do a will. The fact is that after signing a will you are completely free to tear it up and make a new one at any time. You are also free to buy new assets and sell existing ones.

Now, sometimes you may want a particular item (the family Bible, perhaps) or a certain piece of real estate (perhaps the cottage) to be left to a specific person. And if you no longer own those assets when you die, questions arise, such as —

- Is the executor supposed to buy a replacement, or does the person get nothing?

- If the deceased gave the asset to the person named in the will before death, does the rest of their gift get reduced accordingly?

Rather than leave these thorny issues to be settled after your death, often at great expense to your estate and great heartbreak to your loved ones, you can simply answer them in your will by giving clear directions about what to do if one of these situations occurs.

1.5 "Doing a will means I'm ready to die — and I'm not!"

This is a very common excuse, and not as silly as it may seem. After all, who wants to sit around thinking about what has to happen after they are dead? Most of us have a hard enough time getting a handle on what has to happen while we are alive!

But when you think about it, it is just another excuse. There is no scientific evidence that I am aware of that proves that people who do wills are more likely to die than people who don't. Fear of death is a very real fear for everyone, but it isn't a good excuse for not doing a will.

The fact is that after signing a will you are completely free to tear it up and make a new one at any time.

1.6 "I'm too busy right now"

So who isn't busy? This must be the secret mantra of contemporary western civilization. Of course we are too busy: modern life is designed to make us all too busy. Ironically, authors are making fortunes from books on how to take the "busyness" out of life, which people faithfully buy, then are too busy to read!

Most of those books talk about the need to prioritize, and to stick to those priorities. If you've read this far in this book then I bet one of your priorities is to make a thoughtful, comprehensive estate plan. You would rather leave your loved ones a solution than a problem. If that is so, then you are prepared to make time in all the busyness to get that done, and you will.

2. The Three-Step Estate Planning Process

The three-step estate planning process is the quickest way of getting the job done, and it works for almost everyone.

By now you probably realize that you need to have a complete estate plan. You know you have an obligation to yourself, and your family, to do this. But, like so many people, you never seem to get around to it. If you could only find the time. You work and have children and the days are too short for all the ordinary things you have to do.

You need an organized, understandable way of getting this done. That's where the three-step estate planning process comes in. It is the quickest way I know of getting the job done, and it works for almost everyone. Furthermore, it follows the natural understanding of these issues that most people already have. The three-step estate planning process is this:

(i) Organize your property into the three types (see Chapter 1).

(ii) Design your three estate-planning documents in harmony with your probate-free assets (see Chapters 3 to 8).

(iii) Get the three estate-planning documents done and properly signed (see Chapters 9 and 10).

At the end of this book (Appendix 2), I have included a worksheet of the entire three-step estate planning process that will help you work through everything you need to plan your estate and make some important decisions. As you work your way through this book, you will find sections of the worksheet distributed according to the information detailed in specific chapters. Worksheet 1, at the end of this chapter, shows the first step of the estate planning process: Getting Ready.

3. The "Musts" and "Mays" of Estate Planning

It sounds easy, but designing your estate planning documents is like writing a play that you will never get to see on stage — because it will never be performed until one of two things happen:

- You die

- You lose capacity

Since you won't be around to see the performance — or if you are, you won't be able to enjoy it — you must write a great script that spells out what must happen. But having a great script is not enough. The greatest play is only words on a page until brought to life on the stage by actors. And the greatest actors are only a collection of talented individuals until they are taken in hand by a clear-minded director.

The person who will direct your play is your surrogate decision-maker. Every surrogate soon discovers that acting on one of these planning documents is much like staging a play: there are things that must happen exactly as the playwright says, but there are other things that may happen that haven't been spelled out in the text and are left to the director's judgment. These are the "musts" and the "mays" of estate planning.

The musts of estate planning are things that *must* happen exactly as you say in your document. The mays are things that *may* happen, and will have to be decided by your surrogate decision-maker.

> Designing your estate planning documents is like writing a play that you will never get to see on stage.

When you are deciding on the musts — when you say "who gets what, when" in your will, for example — you are in charge, even if you are incapacitated or dead, and your surrogate must do whatever you say.

But with respect to the mays — things that may or may not happen — you can't possibly be in charge. It's the surrogate's job to make the decisions that might come up after you are out of the decision-making picture. That's why it's so important to choose the right surrogate, and to give that surrogate the broadest possible discretion to make good decisions that are in line with your personal wishes, values, and beliefs.

The musts and the mays are unavoidable, simply because it is impossible to anticipate everything that might happen when writing an estate planning document. Like it or not, the future doesn't go away, even after you are dead or incapacitated. The good news is that you get to pick the best person to do something about things that you never thought of — things that may come up when you are no longer able to make decisions about them.

So the challenge is to write a document that —

- describes the musts in the most narrow, detailed, and understandable way, and

- picks the best surrogate to make decisions about any mays that crop up by giving him or her broad, general, and flexible authority in your document, plus an idea of how you feel about things.

Chapter 3 discusses what you need to know to choose a surrogate decision-maker by discussing the first of the three estate-planning documents: the will and how to choose an executor.

> It's the surrogate's job to make the decisions that might come up after you are out of the decision-making picture.

1.1 Personal information

Full legal name _____

 Home address with postal code _____

 Phone with area code _____Fax _____

 E-mail_____

 Social Insurance Number _____

Employer _____

 Address _____

 Phone _____Fax _____

 E-mail_____

Your date and place of birth _____

Citizenship _____

Date and place of marriage(s) _____

Date and place of divorce(s)_____

Maintenance obligations _____

Name of current spouse (including common law spouse)_____

Does spouse suffer from disabilities or handicaps? _____

If so, details_____

Children (by spouse or otherwise) _____

 Names _____

 Dates of birth _____

 Are they married? _____

Do they have children? _____

 Names _____

 Dates of birth _____

 Do any suffer from handicaps or disabilities? _____

 If so, details _____

Professional advisors (name, address, phone, fax, e-mail for each)

Lawyer _____

Accountant_____

Financial planner _____

Insurance agent_____

Clergy _____

Doctor _____

Last tax return filed

 Year _____

 Prepared by _____

1.2 Asset information

1.2.1 Probate-free assets

 Joint assets with right of survivorship:

 Joint real estate:

 Name of co-owner _____

 Address _____

 Legal description _____

 Type (check these as appropriate):

 ❏ House

 ❏ Cottage

 ❏ Farm

 ❏ Condo

 ❏ Acreage

 ❏ Rental property

 ❏ Commercial property

 ❏ Leases (apartment, office, mineral rights)

 ❏ Bare, undeveloped land

Joint cash assets:

Co-owner _____

Financial institution _____

Address_____

Account number_____

Location of papers _____

Type: (check these as appropriate)

❏ Joint bank accounts

❏ Canada savings bonds

❏ Term deposits

❏ Guaranteed income certificates

Other joint investments:

Stocks or shares

Co-owner_____

Issuing company_____

Location of certificate _____

Mutual funds

Co-owner _____

Issuing company _____

Who to contact_____

Designated beneficiary assets (name, address, phone number of beneficiary):

Life insurance products

Life insurance policy

Company _____

Policy number _____

Location of papers_____

Name of beneficiary_____

Address _____

Phone number _____

Segregated mutual funds

Account number _____

Contact info_____

Name of beneficiary _____

Address _____

Phone number _____

Registered plans

Registered Retirement Savings Plan (RRSP)

Financial institution_____

Plan number _____

Name of beneficiary _____

Address _____

Phone number _____

Registered Retirement Income Fund (RRIF)

Financial institution_____

Plan number _____

Name of beneficiary _____

Address _____

Phone number _____

Locked-in Retirement Account (LIRA)

Financial institution_____

Plan number _____

Name of beneficiary _____

Address _____

Phone number _____

Employment pensions

Employer _____

Plan administrator _____

Address _____

Phone number _____

1.2.2 All the rest (sole ownership assets)

Real estate

Address_____

Legal description _____

Check as appropriate:

- ❏ House
- ❏ Cottage
- ❏ Farm
- ❏ Condo
- ❏ Acreage
- ❏ Rental property
- ❏ Commercial property
- ❏ Lease (apartment, office, mineral rights)
- ❏ Bare, undeveloped land

Cash accounts

 Financial institution _____

 Financial institution _____

 Branch address _____

 Branch phone number_____

Investments

 Financial institution _____

 Financial institution _____

Personal property of value

 Vehicles

 Make, model, year _____

 Collections (itemize)_____

 Tools (itemize) _____

Family heirlooms or other items of unusual emotional value_____

Debts owing by family members (details) _____

 By others (details) _____

Location of important papers:

 Safety deposit box

 Financial institution_____

 Branch address_____

 Location of key_____

Debts outstanding

 Mortgage

 Financial institution_____

 Branch_____

Line of Credit

 Financial institution_____

 Branch _____

Credit cards

 Issued by _____

 Account number _____

Bank loans

 Financial institution_____

 Branch _____

Other (give details) _____

3

Planning for Death: Choosing an Executor for Your Will

A will, in its simplest form, is the estate planning document that says where your assets are to go after your death, and who is in charge of carrying out those instructions for you. The people you designate to receive a share of your estate are called your beneficiaries, and the person who is in charge of distributing your estate is called your executor.

Let's go back to the idea of a play for a moment. Just as a play has a logical structure that helps move the action along, a well-drafted estate planning document has a logical structure designed to make sure the job gets done. The will is no exception.

There are as many structural variations to a will as there are lawyers, but when you analyze modern wills you find that most of them can be broken down into three distinct parts. Each part has a distinct function and each asks a fundamental underlying question, as summarized in Table 3.

The very way your will is organized on paper points to the importance of your executor and the job you are asking him or her to do. Being an executor is a large and important job, and it makes sense that you understand what is involved so you can pick the best person for the job. Let's do that by looking at each part of a typical will and seeing what the answers to each of the underlying questions are.

TABLE 3
THE LOGICAL STRUCTURE OF A WILL

Legal name	My name	What it does	Underlying question
Initial matters	The set-up	Appoints your surrogate decision-maker (executor) and makes other preliminary choices	Who will be my executor?
Disposition of assets	Who gets what, when	Sets out the "musts" (the things your executor must do)	What must my executor do?
Executor's powers	The executor's tool box	Gives your executor discretion to deal with the "mays" (the things that may or may not come up)	What does my executor need in order to handle the mays?

1. The Set-up, or *Who Will Be My Executor?*

To decide who your executor will be, you need to ask two more questions:

- What does an executor do?
- Who would be a good executor?

1.1 *What does an executor do?*

At its simplest, your executor's job is to —

- find all your assets,
- pay your bills, and

- hand out everything that is left to your beneficiaries according to the instructions you leave in your will (the "who gets what, when?").

This should be easy, shouldn't it? I'm sure you are the sort of person who methodically files all your important papers in clearly labelled files in a tidy filing cabinet. You routinely update those files, throw out anything that isn't needed and open new ones as you acquire new assets. You keep track of all your insurance policies, investments, bank accounts, and credit card balances, and you have copies of your tax returns going back at least ten years. You never throw out anything important, by mistake or otherwise.

In short, you consciously make an effort to keep everything in such good order that if a total stranger had to walk in your front door tomorrow to find and sell everything of value owned by you or owed to you, it would take him or her only 15 minutes to find everything needed to determine exactly what your estate consisted of, where it is located, what financial institutions you dealt with, and what it is all worth.

However, maybe you aren't so organized. At your house, unopened envelopes are spilling off the top of the fridge and disappearing in the dust-bunny jungle behind it. Tax returns are in a boxes in the basement labelled "summer clothes" or "baby pictures." Insurance is something that you know gets paid every month because the insurance company has this maddening way of automatically taking the money out of your bank account before you get around to paying your credit card bill, and there is never enough to pay that off in full.

Welcome to the world of the executor. Most of us don't know what that world is like. We've never had to try to be loyal to the wishes of someone else who can only speak through the words on the pages of a document, especially a document that we have never seen before and had no hand in creating.

I spent 20 years practising law, during which I drafted hundreds of wills, but I didn't have a clue what the average executor

Welcome to the world of the executor. Most of us don't know what that world is like.

Trust companies are routinely named as executors in wills, and a big part of the trust officer's job is doing executor work on behalf of the company.

was up against until I started working as a trust officer for a trust company. Trust companies are routinely named as executors in wills, and a big part of the trust officer's job is doing executor work on behalf of the company. As a result, I discovered what it was like to walk into the residence of a stranger to look for and protect assets, and how long it would take before we could distribute them as directed in the will.

Usually, these were the residences of older people who were alone. They may have outlived their spouse. They may have had children who were not chosen as executors for a variety of reasons. Perhaps the children were estranged from the deceased or just living far away. In any event, the deceased had chosen to appoint a trust company as executor. Now it was the executor's turn to act.

The estate department staff clips the obituary from the newspaper. It lands on the desk of a trust officer who will act as executor, who searches the vault for the will. What does that trust officer know about that deceased? If he or she is lucky, the trust officer will have an intimate knowledge of the person based on years of assisting with management of accounts and other assets already held by the trust company. Perhaps the trust officer had recently helped the deceased update the will, and has the most current information possible on assets and next of kin. The trust company might even have been preparing annual tax returns for the deceased, which contain a wealth of asset information.

Often, however, the trust officer doesn't have a clue who this person was. How could that be? Well, perhaps the will was written 30 years earlier and the deceased moved several times over the years without informing the trust company. Perhaps the trust officer who worked with the deceased is long retired. Perhaps the deceased didn't have any accounts with the trust company at all. Perhaps the lawyer who made the will didn't send a copy to the trust company. Or perhaps the trust company does have a file but the names and addresses of the beneficiaries are hopelessly outdated. How many times can a person move or re-marry in 20 or 30 years?

The deceased may have died after spending years in a nursing home, and the assets have all been converted to cash and invested. Finding them and doing what the will says may not be difficult. But if the deceased died at home, then the job gets bigger. We often went in with rubber gloves to empty out the fridge, dispose of goods, and take inventory of household items that were part of the estate.

The trust officer has to search every dresser drawer, housecoat pocket, old envelope, cardboard box, and kitchen cupboard for important papers, to be sure a crumpled-up savings bond, a diamond ring, a stock certificate, or a $1 000 bill doesn't inadvertently go out with the trash.

Notice we haven't even begun talking about the biggest part of most estates — handing out the money and assets to the beneficiaries. Those, too, may or may not be difficult to find. If the deceased kept organized records and filed tax returns annually, it's easy. But many people are not very organized, and many don't file tax returns at all. Then the sleuthing begins.

And don't forget the deceased's bills, which have to be paid. These run from the obvious — the last phone, cable, heat, light, and water bills — through to the funeral and burial expenses and less obvious things like credit card bills, loans, and debts. Above all, don't forget that the Canada Customs and Revenue Agency is also looking for its share of the pie.

If all this seems like a lot of work for a trained professional like a trust officer, what about the person who has never done anything like this before and has to try to squeeze it all in between getting the children to school and going to work? How do you know you are picking the right person for the tough job of executor?

1.2 *Who would be a good executor?*

It's an understatement to say that being an executor is a big job and that it takes time. In fact, the law gives the executor one year from the date of death (referred to as the executor's year) to get the average estate done. Here is a list of some of the more common

> The trust officer has to search every dresser drawer, housecoat pocket, old envelope, cardboard box, and kitchen cupboard for important papers.

things that your executor must be aware of and take care of during that first year:

- Look after funeral arrangements
- Notify necessary people and institutions of your death
- Find your will
- Make sure it is your last will
- Find all your assets
- Make an inventory of your assets
- Determine the value of your assets at the date of death
- Determine the original purchase price of any assets that might attract capital gains tax
- Take control of your assets
- Insure and protect your assets
- Apply for pensions, annuities, insurance proceeds, and government benefits payable to your estate
- Prepare the probate application
- Establish an estate bank account
- Sell assets as required
- Advertise for creditors
- Pay your debts
- File any necessary tax returns
- Pay taxes
- Obtain a tax clearance certificate
- Locate beneficiaries
- Distribute the assets as your will requires
- Set up and fund any trusts in your will
- Prepare estate accounts
- Distribute accounts to beneficiaries as required
- Prepare releases for beneficiaries

- Send releases to beneficiaries

- Distribute assets after releases come in

- Pass accounts with the court, if required

- Review life insurance policies and advise insurance companies of the death

- Advise joint owners of the death

That's quite a list, and the truth is it is a rather simplified list. But you get the point: your executor needs to know what he or she is doing. See the *Probate Guide* for your province, published by Self-Counsel Press, for more information on probating an estate.

2. Who Gets What, When? or *What Must My Executor Do?*

There are only two ways to give assets to beneficiaries in a will:

- Make a gift (the executor must pay the beneficiaries as soon as legally possible after your death)

- Put them in trust (the executor must put assets into trust and hold them until some specified future point as directed in the trust document)

When your instructions are to make a gift, you have created an immediately distributable estate, often called an ID estate. When your instructions are to set assets aside in trust and hold them until a future event, you have created a trust estate.

Of course, both may be found in one will: you can tell your executor to pay some beneficiaries as soon as possible, and to hold the rest for other beneficiaries in trust. This is done when some of the beneficiaries are incapable of handling the money on their own for various reasons (e.g., they might be too young or seriously disabled).

Actually, there is a third way to transfer assets in your will. You can give them to beneficiaries for their use and enjoyment during their lifetime, with a proviso that on their death the assets

> When your instructions are to make a gift, you have created an immediately distributable estate, often called an ID estate. When your instructions are to set assets aside in trust and hold them until a future event, you have created a trust estate.

go to someone else. This is called a life estate with a gift over. It was commonly used in the days when the husband owned the house and property in his own name, and he wanted to give that property to the children, subject to the right of his wife to live there and enjoy the benefit of it for the rest of her life. However, this approach is not very common today for two reasons:

- Most couples own their house jointly with right of survivorship.

- A trust can be used to accomplish the same thing with specific clauses that reflect the needs of each situation.

To better understand the role of the executor, let's look at the example of our young married couple who have only probate-free assets.

We have already seen that if one of them dies, the transfer of joint assets to the survivor is automatic. The executor must, however, still attend to all the items listed above. Since the will would handle only assets acquired by the deceased in his or her sole name, and since our couple know all about each other's assets, there shouldn't be any surprises. Who would they pick as executor of their respective wills? The obvious choice is each other, which is what the majority of married couples do.

The problem gets much more complicated, however, when the survivor dies. There most likely aren't any probate-free assets because everything was transferred into the name of the surviving spouse when the other died. This means that everything will pass under the survivor's will. Let's assume that there are young children and the will says that everything is to be held in trust until the children reach age 21. Already a new problem has arisen: the executor must set up and fund a trust for the children. Our executor is now taking on a whole new set of responsibilities (that of a trustee) that will go on as long as there is money in the trust.

Some wills appoint a separate person, a trust company, or a combination of these two as the trustee for the children.

Some wills appoint a separate person, a trust company, or a combination of these two as the trustee for the children. That is often done if the estate is large and the money will have to be managed for a long time. Most trust companies won't touch an estate under $500 000 — and they charge generous fees for the

service. If the children are handicapped or unable to mange money for other reasons, then the money could be in trust for a long time after the age of majority.

These are some of the new responsibilities that go along with being a trustee:

- Invest the estate prudently within the limits prescribed by the Trustee Act of the province, or in harmony with special investment instructions in the will

- Monitor the trust investments carefully, keep accurate records, and be prepared to report to the authorities or the family as required

- Make reasonable payments from time to time for the up-keep of the children, if the will so states

- File tax returns annually for the trust (trusts are taxable entities in Canada)

- Become intimately familiar with the clauses of the will regarding investments and the trust

- Know when he or she can and cannot hire help and determine a reasonable fee to pay for it

- Understand the basic principles of trust law, such as not delegating decision-making to others, maintaining an even hand among beneficiaries, and avoiding a conflict of interest with the trust and the beneficiaries

> The executor's job gets much more complicated if there is a trust to look after, and these trustee responsibilities usually last for a long time.

In other words, the executor's job gets much more complicated if there is a trust to look after, and these trustee responsibilities usually last for a long time.

3. The Executor's Tool Box, or *What Tools Does My Executor Need to Handle the Mays?*

Welcome to the secret place where the sun never shines, as far as estate planning goes. Every will I've ever seen has this dark side. It's the place where the executor's powers — the tools the executor

might need to handle the mays — are spelled out, and most people sign their wills without a speck of light ever being shed on these critical clauses.

That's because these important and basic tools are usually written in that dense, turgid, and utterly incomprehensible language that only lawyers can write. The sentences run on and on. The paragraphs have no headings. There is no apparent organization. Some of the words are still in the Norman French that came over the English Channel with William the Conqueror in 1066!

Most people look at this and cringe. If you have seen this language and didn't understand it, don't worry — you aren't supposed to. Lawyers work exclusively with words. Without their own special language, how is anyone supposed to distinguish what they do from what everyone else does? Right?

Maybe not. People today want to know what the words mean, and why they are there. And if the words don't serve a purpose, more and more people want them out. Unfortunately, when asked about these words, many lawyers recite the creed: "Those? Those are our standard clauses. There's nothing there to worry about, we put them in every will."

But that just asks more questions. The first one that comes to mind is "Why?" Often the explanation is pretty short. To be fair, it's partly a function of the circumstances — by the time you see these clauses, the will is usually in its final form, ready to be signed. Also, as we will see later, many lawyers aren't making a lot of money doing wills, and may feel no incentive to spend a lot of time explaining technical details about clauses that may or may not be needed by the executor. All fair and good, but hardly an answer to a legitimate question.

As a way of taking both myself and the client off this embarrassing hook, I spent some time reviewing my sample will, rewriting the most common executor's powers, inserting explanatory headings, and inserting explanations. They are found in the will in Sample 2, which you will find at the end of Chapter 4. As you review them, keep in mind my premise — the

Many lawyers aren't making a lot of money doing wills, and may feel no incentive to spend a lot of time explaining technical details about clauses that may or may not be needed by the executor.

main character in your estate plan isn't you, it's your executor — and think of how these powers might come in handy for your executor after your death.

To give you an idea of some of the "mays" that could arise in your will, Sample 1 provides five scenarios that would pose problems for your executor, as well as possible clauses that could be inserted into your will to help him or her make a decision.

4. The Most Important Person in Your Will Isn't You

By now you have discovered a host of reasons why you have to pick the right person for the executor's job. The term "executor anxiety" refers to a little known psychological condition that paralyzes people and prevents them from getting the job done. Because they can't think of the perfect person to be their executor, they never get around to signing their wills. Logically, there are only so many possibilities to choose from. You can pick from one or more of the following:

- An individual (e.g., a friend or relative)
- A professional person (e.g., a lawyer, accountant, clergy member, financial advisor)
- A corporate executor (e.g., a trust company)
- The public trustee

You can have more than one executor, and you should have one or more backup choices. The combinations are endless, but the most common arrangements are:

- Sole executor plus one or more alternates
- Two or more executors plus one or more alternates

Note that you can "mix and match." For example, you can have an individual plus a trust company together, or an individual plus the public trustee as an alternate. Let's look at the advantages and disadvantages of each.

The term "executor anxiety" refers to a little known psychological condition that paralyzes people and prevents them from getting the job done.

DEALING WITH THE "MAYS"

Example 1

The deceased may own a boat, a snowmobile, and a used car of approximately equal value. The will may say that everything is to be divided equally among three sons. Ordinarily, the executor would have to get these appraised, then sell them and divide the cash. With the following power, he or she can just give one each of the items to each of the three sons:

```
DISTRIBUTION IN KIND

To transfer the assets of my estate to my beneficiaries
without converting them into cash when that is reason-
able. For this purpose my Trustees will determine the
value of the assets involved and their valuation will
be binding.
```

Example 2

The deceased may own a house that is rented out. Ordinarily the executor is required to sell it and distribute the cash as quickly as possible. But what if the deceased died in the middle of January, the temperature is 40 below, and the real estate market is also in a deep freeze? This power gives the executor the chance to wait for the weather, and the market, to warm up:

```
REALIZATION AND SALE

To realize and sell my estate assets on terms my Trustees
think advisable. They may delay conversion until it is
advantageous. They can hold assets in the form that they
are in at my death even if the assets are not approved
for Trustees. They will not be responsible for any loss
which may occur from a properly considered decision to
leave investments in the form that they were in when I
died.
```

Also, this power gives the executor the right to deal with the tenants and give them the appropriate eviction notices:

```
EXERCISE OF PROPERTY RIGHTS

My Trustees may exercise any rights that arise from
ownership of any property of my estate. This includes
the right to conduct any legal actions necessary with
respect to the estate property.
```

Example 3

What if the death occurs right when the executor is overwhelmed by pressures of his or her own job and family responsibilities? This power allows him or her to hire an agent, such as a trust company, a lawyer, or an accountant to assist with the administration of the estate:

```
EMPLOYMENT OF AGENTS

To employ any agent to carry out the administration of
my estate and its trusts.
```

Example 4

No one knows what the tax laws are going to be when they die. Many of us aren't sure exactly what the tax laws are now while we are alive. This power lets the executor take whatever steps he or she can to minimize the amount of tax payable as a result of the death:

```
TAX ELECTIONS

To make any elections available under the Income Tax
Act of Canada or any other applicable statute.
```

Example 5

Often, disputes break out after a death. These may be full-blown legal battles over the validity of the will itself, or they may be arguments over family heirlooms, such as who should get the grandfather clock. This power directs the executor to consider all reasonable ways to resolve such disputes before plunging into court action:

```
RESOLUTION OF DISPUTES

If any disputes should arise regarding:

   • the administration of my estate;

   • the interpretation of this Will; or,

   • any other matter connected with my estate;

I give my Trustees power to retain the services of any
competent mediator or arbitrator, as they see fit. It
is my intention that the costs of resolving any disputes
be kept to an absolute minimum and that litigation be
used only as a last resort.
```

4.1 An individual as executor

The unavoidable temptation is to give the job of executor to a family member or friend, and that is what the majority of people I worked with did in their wills. As we saw in the example of the young married couple, there is nothing wrong with that if a person dies with only probate-free assets. However, as we also saw, the executor's job gets serious whenever the surviving joint owner dies, or there are substantial probate assets, or the will sets up ongoing trusts.

The law allows executors to hire an agent to assist them with some or all of their tasks.

Then you have to ask yourself if your friends or relatives are capable of handling all the responsibilities outlined above. Are they comfortable with this kind of work? Have they been involved in something like this before? Will they have the time? Do they know how to keep track of everything and prepare financial statements? Have they had experience working with lawyers, accountants, and financial institutions? Are they prepared to file the necessary tax returns? What about the emotional aspect of all this — can the individuals do this at a time of grief and loss? Daunting, isn't it?

But an individual executor is not condemned to suffer alone. The law allows executors to hire an agent to assist them with some or all of their tasks, and most individual executors do that, especially if they need to probate the will. (Probate tasks are whatever needs to be done to get the will through probate so you can then turn to doing what the will says, which is usually called administering or settling the estate.) Some executors hire lawyers to do the probate tasks, then do the estate administration work themselves. Some hire lawyers (or trust companies) to do both.

If the executor hires a lawyer, the lawyer's responsibilities for a routine estate can include the following:

- Taking instructions from the executor

- Advising how legal fees will be charged

- Reviewing the will and the government default laws if appropriate

- Getting information from the executor about the deceased and the beneficiaries
- Getting full information about the estate assets and debts
- Preparing all documents required for probate
- Preparing notices for beneficiaries
- Notifying the surviving spouse of his or her rights, if relevant
- Notifying dependants under dependant relief laws, if any
- Notifying the public trustee, if necessary
- Filing the probate application at the relevant court
- Obtaining probate documents and advising the executor
- Preparing and publishing a notice to creditors, if necessary
- Preparing documents for transfer of stocks and bonds of deceased, if necessary
- Preparing documents for transfer of real estate of deceased, if any
- Advising the executor on any trusts in the will
- Advising the executor about filing tax returns for deceased and estate, if necessary
- Obtaining approval of beneficiaries for executor's claim for compensation
- Preparing releases for signature by beneficiaries
- Otherwise advising and assisting the executor

The estate lawyer may also be asked to do any of the following, depending on the estate and the needs of the executor:

- Handle the entire transfer of estate land to beneficiaries or joint owners
- Act on the sale of estate property or businesses
- Prepare executor's accounts and forward them to beneficiaries for approval

You can change your executor at any time by changing your will. Also, just because you named someone as executor doesn't mean he or she has to do it.

- Prepare all documents and appear in court if a there is a challenge to the will and a formal hearing is required

- Represent the executor in any negotiations with tax authorities

- Arrange for probate in other jurisdictions if necessary (e.g., if the deceased owned land in another province)

- Deal with any claims by creditors

- Set up any trusts required by the will

- Assist with transfer of probate-free assets

At the very least, you should ask the person you are considering for your executor before you put him or her in your will. It's only polite. And you should know that an appointment in a will is not written in stone. You can change your executor at any time by changing your will. Also, just because you named someone as executor doesn't mean he or she has to do it. An executor has the right to refuse when the time comes, in which case your backup takes over.

4.2 A professional person as executor

Many people ask their lawyer or another professional advisor whom they respect and trust to be their executor. Some professionals are willing to do so, others aren't. Be sure to ask first, and don't be surprised if the answer is "No, thanks." Here is a list of some of the questions that professional advisors ask themselves before agreeing to be an executor:

- How will I charge for this?

- Are there any family conflicts that might make this task difficult?

- Am I insured for this?

- Can I still perform my normal professional services, at my normal rates, for this family?

- Do I have the time to do this and my normal work too?

- Do I know enough about executor's responsibilities?

- Is this going to be like the last estate I got mixed up in?

- How will I get paid?

I purposely put the matter of getting paid in twice. The question of fees will never be very far from the surface of professionals' minds, not because they are mercenary, but because they know that being an executor is a lot of work that could easily interfere with the operation of their normal business. When it gets right down to it, don't be surprised if they err in favour of their true calling. After all, if they had wanted to be professional executors they would have gone into that business in the first place. They are usually happiest if they can assist the executor by providing the specialized services that they are geared up to provide, at their usual rates.

Because lawyers work with wills and estates, many of them are willing to be appointed as executor for their clients.

The one exception to this is lawyers. Because lawyers work with wills and estates, many of them are willing to be appointed as executor for their clients. However, the same questions come up, especially the one about fees. A recent Alberta case made it clear that a lawyer acting as executor is not automatically allowed to charge for executor's work on the suggested provincial tariff. The judge recalculated the lawyer's bill on the basis of what was done and how much it was worth, which turned out to be substantially less than the tariff figure. (See Chapter 8 for more information on probate and executor's fees.)

The only way around this is if the lawyer sets his or her executor's fee in advance and it is fixed in the will itself. I never did that, nor did I ever see it done by other lawyers, but it is the preferred method of the next group of potential executors.

4.3 A corporate executor: Trust companies

I practised law for 20 years, and thought that trust companies were simply an alternative to the banks, with more convenient hours. When I went to work for one, I discovered that trust companies were originally established to handle large private trusts

and estates, and they are still in that business. They get this work through their network of retail branches and through contacts they make with other members of the estate planning community, especially lawyers and accountants.

However, their service is not for everyone because of the fees they must charge (their minimum fees for estate administration range from $2 500 to $10 000). An estate must be over a certain value or the trust company cannot profitably take it. The minimum estate size varies, but most trust companies won't get involved unless the estate has at least $500 000 in gross assets.

Even though trust companies are in business to make money, they can't escape the limits put on all executors by the provincial fee restrictions (see Chapter 8). They all have their own standard fee agreements which run to the high end of the provincial scales. These agreements, signed by the will maker when the will appointing the trust company as executor is done, benefit the trust companies because they eliminate the possibility of a challenge over fees when the estate is administered after the will maker, dies. (Manitoba is the only province that requires the agreement be reviewed and approved by the courts when the estate is administered.) These agreements also benefit the will maker, who is also a customer of that trust company because they all provide a reduced fee for administering any assets that are on deposit with the trust company at death.

Nonetheless, a trust company can be a good choice as executor. I recommend them when —

- your estate consists of at least $500 000 gross assets (some trust companies may accept estates of $250 000 if you ask);

- you know that a family feud will break out after you die and you want an experienced neutral party to manage your estate until the dust settles;

- your estate includes complex assets that require sophisticated management or lead to challenging tax problems (e.g., land, a business, publicly traded shares, art collections);

- you have no one to appoint as executor (no spouse, children, friends, or professional advisors who are ready, willing, and able); or

- you are comfortable with their fees.

The advantages of trust companies are that they offer a high level of skill and experience for a fixed fee, and (barring a depression-sized meltdown in our financial system) they will be there, no matter what.

One disadvantage to trust companies is that their fees only make sense for larger estates. Also, with the changes in the financial industry in the 1990s, the banks purchased all the major trust companies (Royal Trust + Royal Bank, National Trust + Scotiabank, Canada Trust + TD Bank), and downsizing, centralization, and telephone call centres are upon us. The days of each trust company having a fully staffed estate department in every city are over, and you or your beneficiaries may be dealing with someone on the other side of the country through a 1-800 phone line.

4.4 Trust companies as agents for executors and trustees

Even if you decide not to name a trust company as your executor, your executor might still hire one to assist with your estate after your death. That is possible under the power that all executors have to hire agents.

However, the law is very strict on how far that can go: an executor cannot delegate any decision-making authority to an agent. What he or she can do is decide what needs to be done and then hire an agent to do it. Many trust companies actively promote their executor assistance services.

For example, an executor may not have the time to drop everything and start sorting through personal belongings, finding assets, insuring them, arranging for a lawyer to get probate of the will, contacting the beneficiaries, and preparing tax returns.

Even if you decide not to name a trust company as your executor, your executor might still hire one to assist with your estate after your death.

That executor might be grateful for the assistance of an experienced trust officer who can explain everything, advise on decisions, and then carry out instructions — for a fee, of course. The fees for these services are usually charged on the executor's fee schedule in effect at the date of death. (See Chapter 8.)

4.5 The public trustee

The final option, often referred to as the executor of last resort, is the government official in your province, called the public trustee. His or her primary job is to look after the estates of people who don't have anybody else. This could include people who are unable to speak for themselves, such as the indigent, the incapacitated, and minors. However, if appointed as executor in anyone else's will, they do accept the appointment if there is no one else available to do the job. The public trustee can be an attractive choice as executor. In my experience, they are knowledgeable, dedicated people, often with years of experience.

> The public trustee is often appointed executor when an estate is taken to court, precisely because of the integrity of the staff and the experience of the office.

The public trustee is often appointed executor when an estate is taken to court, precisely because of the integrity of the staff and the experience of the office. The only caution I have in appointing the public trustee is that in this age of government cutbacks, the public trustee's office in your province may be operating with fewer staff than they would like, and therefore may not be actively looking for new business. Also, they do not work for free, so if you are considering appointing them you should call and ask about their fees.

Choosing the right executor is one of the most important decisions you have to make when designing your will, but it is certainly not the only decision. People ask many questions when they come to see a lawyer about their wills, and answers to many of these questions can be found in the next chapter.

4

Frequently Asked
Will Questions

This chapter covers some frequently asked questions relating to specific content within a will. As well as answering the questions, I have provided some sample clauses that you may consider including in your will. At the end of the chapter is a sample will with some callouts explaining specific clauses in more detail. Worksheet 2, also at the end of this chapter, will help you to personalize the contents of your will.

1. Questions about Content

1.1 Do I have to give something to my spouse?

This is either a dumb question or a front-burner issue, depending on where your marriage is at. Every married client I met took it for granted that the deep bonds of matrimony gave his or her spouse a basic right to all, or at least a significant part of, the estate in the will. But every divorced client for whom the bonds of love had become chains of bondage had absolutely no intention of leaving anything to that very same spouse.

The law begins by giving every will maker the right to testamentary freedom. That means you can do whatever you like in your will. But then another law (often called the Dependants' Relief Act — see Table 4 for the name of the law in your province)

whittles that down by giving protection to people who are financially dependent on the will maker — the spouse and children. Details of these laws differ in each province, but the general idea is that a will maker must provide for his or her spouse and their children. If not, the spouse and children can apply to a court judge to get the will changed so that they receive a fair share.

If your were to leave your spouse out of your will, you might write something like this:

Because my spouse is financially self-sufficient (or because I have already made adequate or generous provision for my spouse during my lifetime) I am not leaving anything further to him/her in my will.

TABLE 4
DEPENDANT RELIEF LAWS

Province/Territory	Name of law
British Columbia	Wills Variation Act
Alberta	Family Relief Act
Saskatchewan	Dependants' Relief Act
Manitoba	Dependants' Relief Act
Ontario	Succession Law Reform Act
New Brunswick	Provisions for Dependants Act
Nova Scotia	Testator's Family Maintenance Act
Prince Edward Island	Dependants of Deceased Persons' Relief Act
Newfoundland	Family Relief Act
Northwest Territories and Nunavut	Dependants' Relief Act
Yukon	Dependants' Relief Act

Matrimonial property laws deal with the consequences of divorce by dividing the property of divorcing spouses. Note that even though divorce ends a marriage, it doesn't cancel a will. That's up to the will maker, and a divorce settlement prepared by lawyers usually says that each person gives up any claims to the will or estate of the other. It may also make any arrangements to continue child support if the person paying it dies before the children reach the age of financial independence.

None of this automatically applies to common-law spouses. Their legal rights did expand in the last decade, but not through broad, overriding provincial laws giving them the same rights as married spouses in all situations. Instead, the changes have come one step at a time through amendments to specific laws governing particular programs and benefits, or through cases decided by judges. These are technical and difficult areas. The best advice for people caught up in these issues is see a good local lawyer for individual advice.

> Dependant relief laws give children the right to support and protection.

1.2 Do I have to leave something to my children?

As mentioned above, dependant relief laws give children the right to support and protection. So even though we all have testamentary freedom, it is restricted as far as children go. However, if your children are financially independent, or are past the age of financial support, then you are free to leave them out of your will if you wish. The age of financial independence and other details vary in each province, so ensure that you get good, local legal advice if this is an issue.

People who are planning to leave someone out of their will always ask if it is a good idea to explain why they are doing that right in the will itself. There are two ways of looking at this. Sometimes the explanation is welcomed and graciously accepted and is a good idea, but sometimes it just fans the flames of anger and disappointment and is a bad idea. I always ask people to think about how they would react if they were on the receiving end of one of these explanations, and then proceed accordingly.

Of course, if the person you wish to leave out has a proper legal claim to some of your estate anyway (under the dependant relief laws, for example), it doesn't matter if you explain your decision or not, they can still make that claim.

To leave your children out of your will, you could write:

Because my children are all over the age of majority and are self-supporting and do not suffer from any mental or physical handicaps that make it impossible for any of them to earn a living, or because I have already made adequate or generous provision for them during my lifetime, I am not leaving them anything further in this will."

1.3 Who will look after my minor children?

You can name someone in your will to be guardian of your children if you die before they reach the age of majority in your province, but your choice is not absolutely binding. That's because people change and things happen. For example, assume you pick your brother as guardian of your children. He may be a good guy today, but what if he becomes an abusive alcoholic? If you don't re-do your will, do you still want your children to automatically go to him? Therefore, whether your will says so or not, the courts have the right to rule on his suitability when the time comes, and to name someone else guardian to protect your children, if necessary.

Parents usually appoint the same person to be trustee of their children's money as well as their guardian. However, if the estate is very large or if the guardian has no skill or talent for managing money, they may choose someone else to be the trustee. This can be a good thing, because you now have two adults working together for the benefit of the children, each having a different area of responsibility — the trustee is looking after the management and investment of the money, including all the record keeping and paperwork (such as filing tax returns for the trusts), while the

> You can name someone in your will to be guardian of your children if you die before they reach the age of majority in your province, but your choice is not absolutely binding.

guardian is looking after the day-to-day decisions, such as where the children go to school, their health care, and their social lives.

1.4 Who will look after my minor children's money?

Most parents assume that if they both die before their children are capable of handling money, their assets should be set aside to be used to raise their children until they are old enough to look after the money themselves. Non-parents may wish to leave money for the benefit of nephews and nieces, the children of friends, or children in general. All these will makers have the same problem: they need a trust. Setting up a trust in a will raises the same three questions that we looked at for the will itself: "Who should I pick as trustee? Who gets what, when? What tools does the trustee need?"

Picking a trustee isn't any different from picking an executor. Many people assume that the executor and trustee will be the same person. However, that doesn't have to be the case. You are free to pick someone else as trustee if you wish. If so, your executor would take charge of your estate and hand over the amount going into the trust when it is legally available for distribution. Your trustee would take it from there, but exactly what does that involve?

Trust funds are held for a long time and must be properly managed. The money must be wisely invested in line with the intentions and directions of the person who set it up. It must be spent for the benefit of the beneficiaries of the trust without prejudice to those who get what is left over when the trust is closed. It's like walking a tight rope, and trustees must walk it without a slip because the safety net is the trustee's own pocket. Their liability is high, and personal. If they slip (i.e., if they don't invest wisely, if they spend too much, or even too little) and there is a loss, they may have to make it up from their own pockets. Do them a favour: when you make a trust in your will, be as clear as you can.

Picking a trustee isn't any different from picking an executor.

Specify precisely when the trust begins and ends, who the beneficiaries are, and what happens if one dies before the trust ends. Make sure the money or property that is going into the trust is accurately described. Allow for resignation or replacement of the trustee. Name an alternate who can step in if the main trustee steps out or is unable to carry on. Permit the trustee to charge a fee for his or her services. Say when and how the fees are to be paid; specify the percentage or the formula or other method for calculating fees.

British Columbia and Alberta publish a list of approved investments for trustees, which may restrict what trustees can invest in.

In particular, give careful thought to your trustee's investment authority. British Columbia and Alberta publish a list of approved investments for trustees, which may restrict what trustees can invest in. The lists don't allow some basic, common assets like real estate or mutual funds in a trust without specific court approval. These lists are very conservative — they favour government bonds, blue chip stocks, and term deposits. They may also be out of date. If you don't expand your trustee's investment powers in the trust document, your trustee's hands may be tied more tightly than you wish — and the trust, and its beneficiaries, may not see the growth or return you expect.

The other provinces have abolished these lists and replaced them with a broader investment power that permits trustees to invest like any prudent investor. However, you have the chance to make your own rules and I recommend that you take it. This area is one where an experienced estate and trust lawyer, or trust officer, can be very helpful.

1.5 What if the whole family dies in a plane crash?

This question contains much of the anxiety about the terrors of technology that characterizes urban myths. Fortunately, entire families don't get "wiped out" very often, but it can happen, and when it does it is terrible.

If you don't say anything about what happens to your estate in that event, the government default will takes over. Why not

use your will-making power to make your own plan? Two common options are splitting the estate between your relatives and your spouse's, or giving it all to a favourite cause or charity.

Unfortunately, the less likely an event is, the more trouble we have planning for it. Many people who make all the other tough will-making decisions stall at this one. Don't let something that has a minimal chance of happening derail all the rest of your good, hard work. If necessary, flip a coin — heads for relatives, tails for the charity — to get past this.

1.6 What if I re-marry?

Divorce does not cancel a will. Most couples in the throes of marriage breakdown have plenty to worry about. On a first-things-first basis, they are pre-occupied with custody of children, alimony, and other immediate issues, and rightly so. Cancelling the mutual wills they signed in happier times — those wills that leave everything to each other if one dies — isn't at the top of that list.

Nonetheless, they must keep in mind that those wills remain valid until cancelled. When the matrimonial property is divided and an agreement signed, a standard clause says that they release any claims against the other's estate. As long as nothing tragic happens before then, there will be no problem. But if a spouse dies before that agreement is signed, and before his or her will is changed, the other partner gets all.

Re-marriage, however, does cancel a will, and it is usually not long before the new couple start thinking about doing new ones. For younger couples with younger children and smaller estates, this may not be a prime concern. But for older couples with grown-up children and lots of assets, it can be a time bomb.

To illustrate, let's assume Mom died at age 60. Dad, who never was much of a domestic engineer, is padding around the big old house alone because the children are far away pursuing careers and raising babies. Inevitably, Dad finds a new companion and proposes marriage. The happy couple tell their children.

Divorce does not cancel a will. Re-marriage, however, does cancel a will, and it is usually not long before the new couple start thinking about doing new ones.

The news is greeted with forced smiles and muted groans. It is unfair to assume that all the children are interested in is their inheritance, but it is often not very far from the surface and, in my experience, it never gets talked about. What upsets the children is the fear that Dad will now be sharing their family assets with someone who isn't part of the gene pool. The fact that the children don't legally own any of those family assets is beside the point — the emotions that these late-in-life second marriages unlock are often ferocious. Successful estate planning in this situation can involve more anger management and prevention than anything else.

It is very important to understand that any marriage, not just a second or subsequent marriage, cancels a will. If you did a will while you were single, make sure you re-do it after you get married. If you don't, the original will is invalid and your estate passes according to the government default laws. The only exception is a will made in anticipation of a specific marriage to a specific person. Such a will must say something like this:

> *I am going to be married to Susan Rich and I am making this will in contemplation of that marriage. Therefore, I intend this will to be valid now and after that marriage.*

2. Questions about Form

2.1 Can I change my mind?

Of course you can change your mind, as long as you haven't made a binding contract not to. (That kind of contract is so uncommon these days it doesn't deserve mention.) Some couples make mirror wills that reflect each other (i.e., they are the same except the names are different). They are not considered joint wills (which say that they won't be changed without the other's consent) and can be changed individually at any time. The important thing to remember is that making mirror wills does not constitute making such a contract, unless the wills expressly say so.

If you do decide to change your will, there are two options:

- You can do a new will and cancel the old one altogether.
- You can do an amendment on a separate piece of paper, which lawyers call a codicil.

I always prefer doing a new will because it is so easy to do — thanks to word processing — and I have found that separate pieces of paper are never around when you need them.

2.2 How is a will executed?

A formal will must be signed by the will maker and two independent witnesses who all see each other sign in the same room at the same time. "Independent" means that the witnesses cannot be a spouse of the will maker, nor can they be a person who is a beneficiary in the will. They must all be adults and of sound mind. Most lawyers also have the will maker and the witnesses initial each page of the will, but this is not necessary for the will to be valid. It does, however, show that all the initialled pages were part of the original will and that nothing was inserted later on.

Any witness who is also a beneficiary in the will is disqualified from receiving anything under that will, whether family or not.

2.3 Can my family be witnesses?

If you intend to give members of your family something in your will, they cannot witness your will. Any witness who is also a beneficiary in the will is disqualified from receiving anything under that will, whether family or not. This discourages undue influence where someone could pressure you into signing a will in his or her favour. After you die you won't be around to explain your reasons so, as protection for you, the law doesn't accept it.

2.4 Does a will have to be typed?

A will can be typed, be in handwriting, or it can be a fill-in-the-blanks form like the *Have You Made Your Will?* forms and disk kit published by Self-Counsel Press. Whatever form it takes, it must be signed by you at the bottom in front of two independent witnesses who see you sign and then sign in front of each other. This

is referred to as a formal will, but it isn't the form of the document that matters, it's the formality of signing it.

Note that Alberta, Saskatchewan, and Manitoba recognize holograph wills. As long as these wills are completely handwritten by the will maker, they needn't be witnessed. Holograph wills, however, are often incomplete or confusing. For example, there may not be an executor appointed, or there may be money in trust for minors, but no trustee is appointed to hold it, or property may be gifted to one person in one paragraph only to be taken back and given to another in the next. I have seen very simple holograph wills that were acceptable, but there are many, many more that are incomplete. If you have one, and are concerned about its legal validity, I recommend you take it to a good will and estate lawyer for review.

2.5 Can I do a will on videotape?

No. A videotape will might be an interesting souvenir, but it is not legal and binding anywhere in Canada at this time.

2.6 Where should I store my will?

When I started law practice 20 years ago, the unspoken rule was that original wills were always kept by the lawyer and stored in the firm's vault, at no cost to the client. Over the past two decades, however, the pendulum has swung in the opposite direction. More and more clients prefer to take responsibility for their original wills. Most often they put them in their own safety deposit boxes at their banks, although some people have more creative ideas like wrapping them in plastic and putting them in the freezer. Regardless, put your will in a place where it will be safe from damage and loss, and where it will be easily accessible when needed.

Let your executor know where it is, and arrange for him or her to have access if necessary. If it is in your safety deposit box, you don't have to give your executor signing authority to enter your box, but you should show him or her where you keep the

A videotape will might be an interesting souvenir, but it is not legal and binding anywhere in Canada at this time.

key. Most banks will let an executor with a key into the box after a death to make a list of the contents and to take out the original will. Then the bank locks the box and doesn't let the executor or anyone else reopen it until the executor returns with a probate certificate from the courts.

Trust companies also store their clients' wills in their vaults. If you are naming a trust company as your executor, you are entitled to this service at no charge.

2.7 When should I review my will?

Lawyers are fond of telling clients to review their wills every five years, or seven, or ten, or whatever number they like. This is good advice that meshes neatly with a lawyer's file re-call system, but it has little to do with people's natural instincts.

There are certain life events that should automatically trigger the thought that the will should be checked — births, deaths, marriages, divorces, inheritances, lottery wins, new jobs, and big moves. If you can raise a red flag in your head every time one of these events happens and take a look at your will, your will then stays current and continues to reflect your wishes.

One of the most commonly overlooked debts is the income tax owed for the year of death.

2.8 What happens to my debts?

Your debts are part of your estate and they must be paid before your executor distributes any of your assets to the beneficiaries. If that doesn't happen, your creditors can sue your executor and collect their money from him or her personally, no matter if all your estate is gone. One of the most commonly overlooked debts is the income tax owed for the year of death, and one of the most powerful creditors is the government. If your executor forgets to file a terminal tax return for you, plus any returns required for your estate, the Canadian Customs and Revenue Agency can quite easily collect it from your executor.

An important part of the executor's jobs, then, is to find all your debts and settle them. He or she does this by going through

all your papers looking for unpaid bills. Your executor can also publish a notice to creditors in the local newspaper. If this is properly done, and if a creditor fails to respond within the stated time, the creditor loses the right to collect its debt.

2.9 What if I move?

All provinces recognize wills signed in other provinces. If you move to another province, you should always have your will checked by a local lawyer to make sure it is in accordance with laws such as the ones dealing with dependants' relief. Also, you might want to re-think your choice of executor, trustee, or guardian, and replace him or her with someone who lives closer to your new home.

2.10 What if I want to donate my organs?

The best way to do this is to sign a declaration under your province's organ donation law and carry it in your wallet. That way, your donation can be immediately identified and acted on in the case of a fatal accident. Otherwise, if you simply write it in your will, you take the risk that your gift may not be discovered until after you are buried or cremated. Many families deal with a funeral before they open the will.

2.11 How do I give a specific bequest?

You make a specific bequest in your will by saying that a certain item or a certain amount of money (a fixed dollar amount or a definite percentage of your estate) goes to a specific person. This is easy to do, but problems can arise if things change after you sign the will. If you no longer own the item at your death, your executor has to know whether you want him or her to buy a replacement to give to the beneficiary, or if you just want the gift to lapse. As for money, if you don't have enough to satisfy the gift when you die, your executor will proportionately reduce the gift unless you say otherwise.

2.12 Burial instructions

It is always a good idea to leave your burial instructions somewhere separate from your will, just in case your friends or family decide to leave the will until after the funeral.

2.13 How can I revoke my will?

You cancel a will by destroying it, by doing a new one that is intended to revoke the old one, or by getting married.

2.14 Can my will be voided?

Your will can be challenged after you die, but only on technical grounds. For example: If your will was not properly signed by you and two independent witnesses in the same room at the same time, it is invalid. Or, if you did not have full mental capacity when you signed it, it is invalid. Also, if you were pressured by someone who made you sign a will that you did not wish to sign, it is invalid if the pressure was truly severe enough to cause you to ignore your own desires and common sense. And, of course, your old will is automatically cancelled when you marry.

Contrary to common opinion, an executor has no power to do anything until you die.

3. What Can My Executor Do While I'm Still Alive?

In a word, nothing. Contrary to common opinion, an executor has no power to do anything until you die. Just because you have done a will doesn't mean that there is someone who can manage your financial affairs or make health care decisions for you if you lose capacity during your lifetime.

To do this, you need the two remaining estate-planning documents: the enduring power of attorney and the advance health care directive. Like a will, these two documents let you make important choices in advance of a crisis — which gives you control over your own affairs and adds up to peace of mind for you and your loved ones. That's what we mean when we say a good estate plan is a plan for life as well as death.

THREE-STEP ESTATE PLANNER: STEP 2: WILL

2.1 The set-up

Sole executor

 Name _____

 Address _____

 Phone number _____

Joint executor

 Name _____

 Address _____

 Phone number _____

Alternate executor

 Name _____

 Address _____

 Phone number _____

Compensation for executor (yes/no)

 In addition to other gifts (yes/no)

Guardian of minor children

 Name _____

 Address _____

 Phone number _____

Joint guardian

 Name _____

 Address _____

 Phone number _____

Alternate guardian

 Name_____

 Address _____

 Phone number_____

 Financial assistance to raise children (yes/no)

Survivorship clause (if mirror wills) (yes/no)

2.2 Who gets what, when

Beneficiaries:

 Names _____

 Dates of birth _____

 Addresses _____

 Phone numbers_____

Typical multi-generational distribution:

 All to spouse (yes, no)

 If no spouse to children (yes, no)

 If child not alive to his/her children (yes, no)

Immediate gifts:

 To whom? _____

 Amounts

 Percentage_____

 Fixed dollar amount_____

 Specific assets (identify precisely)

 If asset not owned at death? (Check one)

 ❑ Ignore gift

 ❑ Replace asset

 ❑ Give cash in lieu

Is there a trust?

 Terms of trust:

 Qualifying age _____

 Compensation for trustee _____

 Death before reaching qualifying age?

 Family wipeout clause (i.e., if no spouse, children, or grandchildren):

 To parents _____

 To charities _____

 Other _____

2.3 Executor's tool box (all yes/no)

	Yes	No
Exercise property rights	❏	❏
Realize and sell assets	❏	❏
Receipt for payments for minor beneficiaries	❏	❏
Distribute assets in kind	❏	❏
Expand scope of investments	❏	❏
Make tax elections	❏	❏
Employ agents to administer estate	❏	❏
Apportion funds received	❏	❏
Encroach on capital	❏	❏
Mediate or arbitrate disputes	❏	❏
Borrow money	❏	❏
Manage real estate	❏	❏
Manage corporate or business assets	❏	❏
Renew personal guarantees	❏	❏

Other (specify) _____

WILL

WILL

THIS IS THE LAST WILL of me, *George Q. Willmaker,* of *Anytown, Anyprovince,* Canada

PART I — INITIAL MATTERS

A. REVOCATION

I revoke all former Wills and Codicils.

➡ *People usually assume that by signing a new will, they are automatically cancelling any old ones, and this clause eliminates any doubt.*

B. EXECUTORS AND TRUSTEES

1. I APPOINT my spouse, *Josephine Willmaker,* of *Anytown, Anyprovince* as the Executor and Trustee of my Will.

2. If she:

a. does not survive me; or

b. is unable or unwilling to act when I die or at any later time; or

c. ceases to be a resident of Canada within the meaning of the *Income Tax Act (Canada),*

then I appoint my brother, *Herbert Willmaker,* of *Anytown, Anyprovince* as Executor and Trustee of my Will

3. I shall refer to the Executor and Trustee of my Will as "my Trustees."

➡ *This clause appoints the executor and alternate, and says when the alternate is to take over. It also allows you to avoid repetition of the phrase "my executors and trustees" in the rest of the will by just saying "my trustees."*

4. My Trustees may pay themselves a reasonable fee for the work they do, in addition to any gift or benefit that I leave them in this Will, provided that the amounts are:

 a. approved by the Surrogate Court; or

 b. approved by all of the beneficiaries of my estate.

> *This reminds executors that they can't take their fees until the fees are approved. Trust companies usually ask for a clause allowing them to "pre-take" fees, meaning they don't have to wait until the estate is finalized.*

C. SURVIVORSHIP

Any beneficiary who is not alive thirty (30) clear days after my death is considered not to have survived me.

> *If a couple with mirror wills dies in a common accident, like a plane crash, where it is physically impossible to determine who died first, there can be confusion over who gets what. The general rule for this situation is to assume the oldest died first. That means all the estate of the older automatically goes to the younger before going to the younger's beneficiaries. With this clause, the two estates are administered together, so the wishes of both are followed.*

D. DISPOSITION OF BODY

I direct that my body be disposed of as my Trustees see fit.

> *You may not know that your executor has the legal right to decide on the disposition of your body, no matter what you say. However, most executors are relieved to find that you left specific instructions about that and are happy to follow them. It is a good idea to put those instructions in a separate document and deliver it to your executor sooner rather than later. If the will isn't opened until after the funeral, it's too late.*

PART II — DISPOSITION OF ESTATE

I give all my property, including any property over which I have a general power of appointment, to my Trustees on the following trusts:

A general power of appointment is a power given to an executor to decide who gets a certain asset. This clause allows for the possibility that our will maker might have such a power as executor of someone else's will, but dies before he carries it out. I never saw such a power in my practice, but lawyers routinely include this clause nevertheless.

A. PAYMENT OF DEBTS

To pay:

1. All my legally enforceable debts;

2. My funeral expenses;

3. The expenses incurred in administering my estate.

A reminder to the executor to pay all debts and expenses before distributing the estate. Don't forget that "debts" includes "income tax."

B. RESIDUE TO SPOUSE

To transfer the residue of my estate to my spouse, *Josephine Willmaker.*

This gives all of the estate to the spouse. If she survives the will maker, then the gifts that follow are ignored.

I am aware of the provisions of the Dependants' Relief Act of my province. I leave everything to my spouse knowing that she will adequately care for our children.

➤ *We discussed the purpose of the depedants' relief acts, on page 60. This covers the situation in which the will maker has children who will continue to live with their mother, and she will use the estate assets to raise them, just as both parents did when the will maker was alive. Under those circumstances, the public trustee does not have to use the dependants' relief act to have assets set aside in trust for the children.*

C. ALTERNATE DISTRIBUTION

If my spouse does not survive me:

➤ *If the spouse is not alive, these gifts come into effect and the alternate executor takes over. This sets up trusts for children.*

1. Children:

a. To divide the residue of my estate equally among those of my children, *Sally Willmaker, Susie Willmaker and Sammy Willmaker,* who survive me;

b. If a child of mine is under the age of twenty-one (21) years, to set aside the share of that child in trust as follows:

(i) To keep that share invested;

(ii) To pay the income or capital of that share or as much of either or both as my Trustees consider advisable for the maintenance, education, advancement, or benefit of that child; and

(iii) To pay or transfer the capital of that share or the amount thereof remaining to that child when he or she reaches the age of twenty-one (21) years;

➤ *This is a typical trust for children. Note that it also says what happens if a child dies before reaching the age of distribution.*

c. If a child of mine dies before becoming entitled to receive the entire principal of his or her share:

 (i) To divide the share as constituted at that child's death among my other children then alive in equal shares; and,

 (ii) If any person becomes entitled under this or any other clause to any interest in addition to a share being held in trust for that person under this Will, to add that interest to and mingle it with that share and to administer it as if it had been an original part of that share.

➡ *There are many possibilities for this part of the will. It is impossible to present one clause for everybody. Please remember that is is a sample will that may work in one common situation. Do not assume it is perfect for you. Make sure that your own will does what you want it to do.*

2. Grandchildren:

a. If a child of mine does not survive me, leaving any surviving children (referred to as my "grandchildren" or "grandchild"), they are to receive in equal shares the share that my deceased child would have received if my child had survived;

b. If a grandchild of mine is under the age of twenty-one (21) years, to set aside the share of that grandchild in trust as follows:

 (i) To keep that share invested;

 (ii) To pay the income or capital of that share or as much of either or both as my Trustees consider advisable for the maintenance, education, advancement, or benefit of that grandchild; and

 (iii) To pay or transfer the capital of that share or the amount thereof remaining to that grandchild when he or she reaches the age of twenty-one (21) years;

c. If a grandchild of mine dies before becoming entitled to receive the entire principal of his or her share, to divide the share remaining at that grandchild's death among his or her siblings then alive in equal shares.

➡ *This clause assumes that the will maker wants to pass assets to his grandchildren if a child of his is not alive. In that case, the trustee is to hold the shares of any grandchildren in trust until they reach the stipulated age. This may or may not be what you want for your estate.*

3. Family Demise

If neither my spouse nor any of my children survive me, or if all of them die before they become entitled to receive the entire principal of their shares of my estate, then to divide the residue of my estate, or the amount then remaining, as follows:

a. to pay or transfer FIFTY (50%) PERCENT to my wife's sister, *Sherry Spinster,* if she is then alive; but if she is not then alive to pay or transfer this share to the *Canadian Cancer Society* for use as their board of directors sees fit.

b. to divide the balance of the residue of my estate equally among those of my siblings, *Syd Willmaker, Marty Willmaker,* and *Shareen Willmaker* who are then alive.

➤ *This is called the "ultimate disposition clause" or the "wipe-out clause." There is an infinite number of possibilities. There is a typical example. Make sure your will reflects your particular needs and wishes.*

PART III — POWER TO ADMINISTER MY ESTATE

To carry out the terms of my Will I give my Trustees the following powers:

➤ *This is the executor's tool box, which we discussed on page 45. The powers below are the most commom ones found in wills. Even though some of them relax the strict requirements that bind executors, your executor must always act honestly, reasonably, and fairly.*

A. EXERCISE OF PROPERTY RIGHTS

My Trustees may exercise any rights that arise from ownership of any property of my estate. This includes the right to conduct any legal actions necessary with respect to the estate property.

➤ *This confirms that the executor takes over management and control of the will maker's assets, and gives him or her the right to deal with law suits, if necessary. For example, as discussed in Sample 1, this gives the executor power to deal with tenants of rental properties owned by the estate.*

B. REALIZATION AND SALE

To realize and sell my estate assets on terms my Trustees think advisable. They may delay conversion until it is advantageous. They can hold assets in the form that they are in at my death even if the assets are not approved for Trustees. They will not be responsible for any loss which may occur from a properly considered decision to leave investments in the form that they were in when I died.

The executor must gather the estate assets and turn them into cash. This is called "realizing" or "converting" the estate. The cash is then invested until the executor is able to distribute it. As discussed in Sample 1, this power allows the executor some discretion about timing the sale of assets, and lets him or her hold onto assets of the deceased that are not otherwise approved for estates.

C. PAYMENTS TO MINOR BENEFICIARY

To make any payment for a person under the age of majority to his or her parent or guardian. The receipt of that parent or guardian will be a sufficient discharge to my Trustees.

A minor can not give a legal receipt for payments or assets received from an estate. This clause lets the parents or guardian do that.

D. DISTRIBUTION IN KIND

To transfer the assets of my estate to my beneficiaries without converting them into cash when that is reasonable. For this purpose my Trustees will determine the value of the assets involved and their valuation will be binding.

As discussed in Sample 1, this allows the executor to distribute assets of equal value without having to sell them.

E. INVESTMENTS

To invest my estate assets in investments that are not authorized for Trustees.

→ *As discussed on page 64, Alberta and BC still publish lists of investments that are approved for trustees. This clause relaxes those requirements.*

F. TAX ELECTIONS

To make any elections available under the *Income Tax Act of Canada* or any other applicable statute.

→ *As discussed in Sample 1, this lets the executor take whatever steps he or she can to minimize the amount of tax payable as a result of the will maker's death.*

G. EMPLOYMENT OF AGENTS

To employ any agent to carry out the administration of my estate and its trusts.

→ *As discussed in Sample 1, this lets the executor hire an agent such as a trust company, lawyer, or accountant to help with the administration of the estate. The executor should remember that these agents are only advisors. Ultimate responsibility for all decisions rests on the executor's shoulders.*

H. APPORTIONMENT OF RECEIPTS

To decide whether receipts are income or capital in their discretion.

→ *There may be times when the executor, on the advice of accountants or other financial advisors, can decide if money earned or received by the estate is income or capital, which may make a difference for tax purposes. This clause makes the choice possible.*

I. ENCROACHMENT POWER

Except as otherwise provided in this Will, if my Trustees hold any share of my estate in trust they shall have the power to spend as much of the income or capital or both as my Trustees consider advisable for the maintenance, education, advancement, or benefit of the beneficiary of that trust.

This is for situations that aren't already covered in the trust for the children or grandchildren. For example, if a grandchild dies before receiving his or her share, this share is then split between his or her children. They would likely be minors, and their portions would be held in trust under this clause. Otherwise, this clause won't likely be needed.

J. RESOLUTION OF DISPUTES

If any disputes should arise regarding:

a. the administration of my estate;

b. the interpretation of this Will; or,

c. any other matter connected with my estate;

 I give my Trustees power to retain the services of any competent mediator or arbitrator, as they see fit. It is my intention that the costs of resolving any disputes be kept to an absolute minimum and that litigation be used only as a last resort.

As discussed in Sample 1, this gives the executor some options if a dispute breaks out after the will maker's death.

K. BORROWING

To borrow money for the estate with or without security.

This clause and the three that follow, are usually required only if the will maker owns a business. They allow the executor to operate the business until it can be sold or closed down in an orderly fashion.

L. REAL PROPERTY

To manage, sell, or lease any real property in my estate on such terms as they choose and to spend such amounts as may be necessary to maintain and repair it.

M. CORPORATE AND BUSINESS ASSETS

1. To represent my estate as a shareholder in any corporations in which it holds shares and to participate in any corporate decisions required.

2. To carry on any business I was engaged in as if I were still alive.

3. To incorporate a company to carry on any business or hold any assets of my estate.

N. RENEWAL OF GUARANTEES

To renew any Guarantees or Securities I may have given to secure the debt of another person and to renew them only for the purpose of an orderly liquidation. I direct my Trustees to do this without undue embarrassment to my family or business associates.

PART IV — GUARDIANSHIP OF CHILDREN

A. APPOINT GUARDIAN

If my spouse, *Josephine Willmaker,* fails to survive me, I appoint *my wife's sister, Sherry Spinster, of Anytown, Anyprovince,* as Guardian of my minor children.

B. FINANCIAL ASSISTANCE TO GUARDIAN
I wish that the resources of my estate be used to prevent any financial burden on my Guardians as a result of their agreement to care for my minor children. I give my Trustees discretion to use the encroachment powers to make such payments as may be reasonable to provide adequate housing and household help and to pay the cost of feeding, clothing, and educating my minor children.

I, *George Q. Willmaker,* have subscribed my name to this my Will on the *1st* day of *Anymonth, A.D. Anyyear,* at the City of *Anytown,* in the Province of *Anyprovince.*

George Q. Willmaker

SIGNED BY *George Q. Willmaker* as his Will,)

in our presence and attested by us in his)

presence and in the presence of each other)

) George Q. Willmaker

WITNESSES:

I.M. Witness

Name: I.M. Witness
Address: (Witness 1)

U.R. Witness

Name: U.R. Witness
Address: (witness 2)

5

Estate Planning for Life: The Law of Aging

Most people who consider doing their wills have no idea that there are any other estate planning documents to be concerned with, but there are. They are related to the law of aging. If you are like most people, you probably won't discover this area of law until you start looking after an aging loved one and you reach a point where your informal decision-making authority falls short. Let me tell you about the kind of phone call I often received in my law office.

Note: For convenience, I am using the terms used in Alberta, which may be different from the ones used in your province. However, these situations — and the basic rules of the law of aging — are the same everywhere, simply because people get old and don't always plan for it, no matter where they live. Refer to Tables 5 and 6 to find out what terms are used in your province.

An aging widower starts to decline mentally and physically. His daughter gradually takes over more and more of the daily chores, like banking, bill paying, and grocery shopping. This informal care works and keeps Dad in his own home for several years.

Unfortunately, Dad reaches the point where he is not safe living on his own at home. He is forgetting to turn off the stove-top burners and is locking himself out regularly. His daughter gets

Dad to sign cheques but he doesn't really know what account is being paid. His daughter arranges for home care to come in twice a week, but that is not enough, and with government cutbacks, she can't get them to come more frequently. It's time for Dad to go to a nursing home, and that is done.

TABLE 5
ENDURING POWER OF ATTORNEY LAWS AND TERMS BY PROVINCE

Province/ Territory	Name of law	Name of document	Name of decision maker
British Columbia	Representation Agreement Act	Representation Agreement for Property or Finances	representative
Alberta	Powers of Attorney Act	Enduring Power of Attorney	attorney
Saskatchewan	Powers of Attorney Act	Enduring Power of Attorney	attorney
Manitoba	Powers of Attorney Act	Springing Power of Attorney	attorney
Ontario	Substitute Decisions Act	Continuing Power of Attorney for Property	attorney for property
New Brunswick	Property Act	Power of Attorney	attorney
Nova Scotia	Powers of Attorney Act	Enduring Power of Attorney	attorney
Prince Edward Island	Powers of Attorney Act	Power of Attorney During Legal Incapacity	attorney
Newfoundland	Enduring Powers of Attorney Act	Enduring Power of Attorney	attorney
Northwest Territories and Nunavut	no law		
Yukon	no law		

TABLE 6
ADVANCE HEALTH CARE DIRECTIVE LAWS
AND TERMS BY PROVINCE

Province/ Territory	Name of law	Name of document	Name of decision maker
British Columbia	Representation Agreement Act	Representation Agreement for Health Care	representative
Alberta	Personal Directives Act	Personal Directive	agent
Saskatchewan	Health Care Directives and Substitute Decision Makers Act	Health Care Directive	proxy
Manitoba	Health Care Directive Act	Health Care Directive	proxy
Ontario	Substitute Decisions Act	Continuing Power of Attorney for personal care	attorney for personal care
New Brunswick	no law		
Nova Scotia	Medical Consent Act	Authorization to give medical consent	deemed guardian
Prince Edward Island	Consent to Treatment and Health Care Directives Act	Health Care Directive	proxy
Newfoundland	Advance Health Care Directives Act	Advance Health Care Directive	substitute decision maker
Northwest Territories and Nunavut	no law		
Yukon	no law		

The house is now empty, so the daughter calls a real estate agent and, even though he is confused, Dad signs a listing agreement. The house is in a stable, central neighbourhood that is popular with young couples.

During a family meeting at the nursing home, a staffer says something about the daughter having to get a substitute decision-making order. The daughter is annoyed. She has been doing everything for years, and nobody ever said anything about a court order before. When she asked for help, the government told her there was no more available. Does the same government mean to tell her that she has to see a lawyer and spend money on some fancy paper just so she can continue doing exactly what she has already been doing and is going to keep on doing no matter what anybody says? The staffer gives her the phone number for the local seniors society, which keeps track of lawyers who do this work. The daughter says thanks, and does nothing.

A few days later, the real estate agent has an offer for more than the asking price. Dad still isn't sure what this is all about, but he dutifully puts his signature on it. Then the agent wants to know where to send the legal work to close the deal.

The daughter calls the senior's society, and they give her a list of lawyers to call. She calls me and asks if I do real estate. I ask some quick questions to get the picture and learn about the pots on the stove, the cheque writing procedure, the nursing home move, the empty house, and the proposed sale.

This was a routine call for me, but it was not a routine situation for this daughter. She had never been through anything like this before. Even though the daughter thought she was just calling about a house sale, I suspected it was much more than that. Here are some more questions I would typically ask:

- Is the title to the house in Dad's name alone?

- If Mom is still a joint owner, have steps been taken to remove her from the title?

- Did Dad really understand the offer when the agent explained it?

- Can Dad call me himself?

- Why is he in the nursing home?

- What do the doctors say about his mental capacity?

- Can he get to my office?

- Is he capable of signing all the other legal documents we need?

- If he can't sign, does anyone have legal authority to sign for him?

- If so, where does that signing authority come from?

- If not, do we have enough time to get legal signing authority before closing?

- Who will look after Dad's money after the sale closes?

- Does the insurance company know the house is vacant?

One institution in every province that requires formal legal authority is the land registration office.

Assuming that the answers are either "No" or "I don't know," I now have very good reason to believe that Dad is no longer capable of managing his affairs, and I can no longer behave as if he is fine. That means that this good daughter is about to collide with the brick wall of the law of aging. She is about to learn about surrogate decision-making for the living.

The daughter has done the right thing; she used her informal authority properly and wisely as far as it would go. Many people and institutions happily accepted her say without question, but there are many who won't, or can't. One institution in every province that requires formal legal authority is the land registration office. Their staff aren't in the business of turning over title to somebody's land on the mere say-so of a well-meaning relative or friend. This is a good thing: I don't want my house being sold or mortgaged by my spouse or a family member without my approval any more than you do. If there is doubt about Dad's ability to understand and sign land documents, relatives can't do it unless they can show specific legal authority giving them the right to exert control over Dad's property.

This kind of formal substitute decision-making authority can only come from one of three places. Unfortunately, a loving relationship isn't one of them. The authority can come only from —

- a general law of the province in which Dad resides, establishing automatic rules for substitute decision-making authority,

- an enduring power of attorney, created and signed by Dad, appointing the daughter, or

- a court order giving her specific substitute decision-making authority over Dad.

The laws allowing for enduring powers of attorney are relatively recent — most were passed in the 1990s.

Only Ontario, PEI, and Saskatchewan have general laws setting up automatic rules. (In Ontario it's the Health Care Consent Act; in PEI it's the Consent to Treatment and Health Care Directives Act; and in Saskatchewan it's the Health Care Directives and Substitute Decision-Makers Act. In all these acts, the person appointed under an advance health care directive is at the top of the list.) Usually, the daughter must look for a specific document signed by Dad, or she has to get a court order.

The chances of a finding an enduring power of attorney are slim, unfortunately. Many people are not aware of them, or if they are, very few have actually done one. Furthermore, the laws allowing for enduring powers of attorney are relatively recent — most were passed in the 1990s. Because of that, and because people who make one usually let the substitute decision-maker know about it, the odds of an enduring power of attorney existing without the daughter knowing it are slim. This means she has to head to court for a court order — words that raise vivid, unpleasant images of lawyers, delay, and cost in most people's minds.

I used to tell my clients to allow four to six weeks from the day we had all the medical reports confirming loss of capacity to the day the judge signed the order. The cost was in the neighbourhood of $1 500 if other family members didn't oppose the request. If they did, then we headed into the open-ended process of

litigation — another legal word that raises vivid and uncomfortable images in people's minds, for very good reason.

If Dad were still competent and could understand and sign his own enduring power of attorney, then we could do that. But if he isn't, the choice is get the court order or lose the sale, and losing the sale is never a good choice. Insurance companies are nervous about insuring vacant properties for too long, and care-givers usually have enough to do without becoming landlords as well — especially when they don't have legal control over the property they will be renting. We inevitably got the court order, but not without a good deal of anger and frustration.

So we solved the house sale problem. However, daughter doesn't know it, but the real story just beginning. This court order makes the daughter a trustee of Dad's assets, and puts some heavy responsibilities on her. These vary from province to province, but in Alberta they include the following:

- She has six months from the date of the order to file a sworn inventory at the court house detailing all Dad's assets and money, not just the house.

- She must file detailed accounts showing what happened to all of Dad's assets — every penny that came in and every penny that went out — and have these accounts reviewed by a judge every two years.

- She cannot pay herself for her effort without court approval.

- She must come back to court to have the order reviewed and continued every six years.

- She does not have power to make personal or health care decisions about the dependent adult (Dad) unless she also asked to be Dad's guardian (a guardian is the person who has authority under a court order to make decisions about health and personal care, while a trustee is appointed under a court order to look after the assets and financial matters).

A guardian is the person who has authority under a court order to make decisions about health and personal care, while a trustee is appointed under a court order to look after the assets and financial matters.

• She can invest Dad's money only in certain assets, unless otherwise permitted.

Obviously, if the daughter is going to be a trustee of Dad under such a court order, she must have the same skills and knowledge as a an executor or trustee under a will. At the very least, she must know how to set up and maintain a good record-keeping system. Otherwise, she, her accountant, or her lawyer will have a box full of two years' worth of paper to sort out at the last minute. That kind of neglect might even lead the reviewing judge to wonder if the daughter was perhaps not the best person for this demanding job in the first place. If the daughter is careless to the point of losing some of Dad's money — or if she uses it for unauthorized purposes — a judge usually has power to dismiss her and appoint someone else. Of course, she would be liable to make up any losses out of her own assets.

This common example amounts to a crash course in the law of aging for the caregiver generation. Faced with a short-fuse crisis around the sale of Dad's house, clients in this situation get the idea the hard way: there is more to competent estate planning than a will. After going over the options, and learning about the demands of the court order, every single one of these clients said, "If only Dad had signed an enduring power of attorney. How much cheaper, faster, and easier this would be." How true. So let's turn back the clock to when Dad was making his will and go over the planning opportunity that he missed — the two remaining estate planning documents he could have done: the enduring power of attorney and the advance health care directive.

6

Your Enduring Power of Attorney

1. What Is a Power of Attorney?

The idea of a normal power of attorney has been around for a long time. It is used in situations where you need someone to do something on your behalf. Let's say you are buying a house, but suddenly your company sends you to South America to supervise a six-month project. You could sign a power of attorney appointing your spouse, your lawyer, or anyone else you trust to sign the real estate papers and wrap up the deal for you in your absence. Once the deal is over, or once you get back, the appointment ends and you take control.

Note: In Canada, the term "attorney" means the person appointed in a document, such as a power of attorney, to handle your affairs. It is different from the term "lawyer," which refers to a person with a law degree who is trained to give legal advice. For more information on powers of attorney, take a look at *Power of Attorney*, another title in the Self-Counsel Legal Series.

2. What Is an Enduring Power of Attorney?

People who plan always thought that something similar to a power attorney made sense for the possible loss of their own mental capacity in the future. They wanted to be able to sign a

document today that would give someone else legal power to take over their financial affairs if they ever became mentally incapacitated. Such a document would be triggered by the loss of capacity.

Unfortunately, the law prevented that. It said that normal power of attorney documents were only as good as the person who signed them, so if you became incapacitated, your power of attorney document was automatically terminated. That raised serious doubts about the benefit of using powers of attorney that were triggered by incapacity for estate planning purposes under the law as it stood. If you signed one anyway, and your attorney acted on it, anything your attorney did would be unauthorized and could have serious consequences for him or her.

The only way to fix that was for each province to pass a law specifically permitting powers of attorney for estate planning purposes, and over the past ten years or so they have done just that. Because each province calls this document something different, I will refer to it as the enduring power of attorney to distinguish it from the normal power of attorney discussed above. (See Table 5 in Chapter 5 to find out the name used in your province.)

> The enduring power of attorney document is very short, often only one page long, covering just the basic points.

No matter what the provinces call these, there is one thing that all the different enduring powers of attorney have in common — they are very short, often only one page long, covering just the basic points. Typically, these documents:

- identify the attorney,
- say when the attorney's power begins, and
- give the attorney "power to do anything I can do by an attorney."

If you were named attorney under such a document you wouldn't have much to go on, would you? You could fill out more detail by reading your province's Power of Attorney Act, but how many attorneys, most of whom aren't lawyers, have a copy of their provincial act in their pockets?

Many lawyers won't be able to tell you much either, simply because enduring powers of attorney are so recent, and few

lawyers have experience being an attorney. Nor do they want it — most lawyers don't want to give up any of their normal fee-generating work to take on the numerous and long-lasting responsibilities of an attorney. However, a large number of enduring powers of attorney written during the past decade are now being triggered. Because many of these documents appoint trust companies as their attorneys, trust officers who have the job of making them work are quickly gaining experience.

Let's look at the issues you should consider when creating your enduring power of attorney. It doesn't matter which province you live in or what the typical document in your province may say; these are general issues that apply to everyone, everywhere. Once you are familiar with these concerns, you will be ready to work on Worksheet 3, the Enduring Power of Attorney worksheet, which you will find at the end of this chapter.

3. What Are the "Maybes" That an Attorney Must Deal With?

Doing a will is difficult for most of us, but doing an enduring power of attorney is even harder. That's because a will is for death and an enduring power of attorney is for life — our own life. The executor of a will has a big job, but he or she does not have the worry of caring for us while we are still living. The executor's responsibility is to get on with what must be done under the will and hope that he or she has all the power needed to take care of any "mays" that could arise (see Chapter 3).

Your attorney, however, doesn't have that luxury. In fact, his or her job is the exact opposite. Your attorney's job, if you become incapacitated, is to protect and manage your estate and to use your assets to look after your financial needs. But the fact that you will still be alive makes the job more complicated. Here are some examples of what your attorney may have to consider:

- You could live for another 6 months or for another 60 years. Your attorney will have to manage your affairs indefinitely and make appropriate decisions.

> Your attorney's job, if you become incapacitated, is to protect and manage your estate and to use your assets to look after your financial needs. But the fact that you will still be alive makes the job more complicated.

- You may be able to afford to stay in your home and hire 24-hour care. Perhaps you can afford to buy or rent in a private, full-service seniors' complex. Or you may have to go to a public nursing home. How will this be decided?

- What does your attorney do if you have dependants who still need financial support?

- Does your attorney keep or sell any rental property you own?

- What if your estate runs short? Does your attorney keep or sell any specific assets you have designated to certain people in your will?

- Can your attorney deal with any specific mutual funds or other investments you have, and sell them if they go bad?

- What if your attorney needs professional help to deal with your affairs? Can he or she get it, and pay for it out of your estate?

- Does your enduring power of attorney allow for your attorney to be paid a fair price for his or her work? How much? When?

- Is your attorney able to get into your safety deposit box to get documents?

- What if your attorney has to sell your house? What should he or she do with the contents?

- If your attorney needs to get summaries of your previous tax returns, will he or she have this power?

- If your attorney is not also your health care agent (see Chapter 7), how is he or she to work with that caregiver?

The point here is that these issues are unpredictable, which introduces a whole new planning problem for you — "the maybes." Most enduring powers of attorney don't say much about the maybes, for good reason. How much luck have you had predicting the future during your lifetime? Life is capricious; things happen, and we don't always see them coming.

Even so, we owe it to ourselves, and to those around us, to plan. While we cannot anticipate every detail and force it to come true, we can make sure we are standing on a firm foundation and are ready to deal as best we can with whatever life throws our way. In that sense, preparing for the possibility of incapacity means that your enduring power of attorney is the foundation and your attorney is the one who needs to be ready to respond to whatever financial challenges arise as a result of your incapacity.

If you know that certain things will happen — for example, your house will need to be sold— then write them down in your enduring power of attorney with clear instructions telling your attorney what to you want him or her to do. The rest you just have to leave in the hands of your attorney, so pick a good one and discuss with your attorney how you feel about the issues listed above so that he or she is aware of and can try to meet your wishes.

Like your will, there are three critical parts to an enduring power of attorney (see Table 7). Each part asks an underlying question that points right to the most important person in the document — your surrogate financial decision-maker or your enduring power of attorney.

Each province has its own technical requirements about who can be an attorney, but, in general, you are free to select any adult person.

4. The Set-up, or *Who Will Be My Attorney?*

Each province has its own technical requirements about who can be an attorney, but, in general, you are free to select any adult person (meaning anyone who has capacity and who your province considers to be of legal age). He or she does not have to live in your province, and there isn't an enduring power of attorney's training course, so no certificates or credentials are required. This gives you very broad scope.

Most people pick a member of their immediate family (i.e., spouse, parent, or child) and leave it at that. But what happens if the spouse becomes an alcoholic or a gambler? What happens if the parent is a good choice but dies, or becomes incapacitated?

TABLE 7
THE LOGICAL STRUCTURE OF AN ENDURING POWER OF ATTORNEY

Part	What it does	Underlying question
The set-up	Appoints your surrogate financial decision-maker (attorney) and backup	Who will be my attorney?
The trigger	Establishes when you have lost capacity and how your attorney knows when to take over	When do I want my attorney to start?
The attorney's tool box	Gives your attorney power and discretion to handle any potential occurrences related to your affairs (the "maybes")	What does my attorney need in order to do the best job?

Just like you did in your will, you can pick a backup attorney, and you should specify when that backup is to step in.

You should look for someone who has all the qualities of a good executor (see Chapter 3), plus the ability to look after any of the financial maybes that might come your way. The critical difference between an executor and an attorney is that your executor has a rough idea of how long the job should take: the executor's year. But how does your enduring power of attorney know how long he or she will be on the job? Your attorney must available for the long haul, just in case.

> The critical difference between an executor and an attorney is that your executor has a rough idea of how long the job should take.

You could choose a relative, friend or neighbour, or a professional person with whom you have a good relationship. Regardless, it must be a person you can trust, because even though you will be there in body, you won't be there in mind to supervise and criticize what he or she does with your hard-earned estate. Many of you are lucky enough to have such a person, and there is no reason not to appoint them if you fee good about it.

If you don't know anyone you feel confident can handle your affairs, you can appoint two or more people and say they have to

make all decisions unanimously. If they can't agree, you can set up a tie-breaking mechanism or you can tell them to get a decision from a judge. Remember, though, that the cost involved in going to court would come out of your estate, and the legal work takes time.

Your attorney could be a professional person such as your accountant or lawyer, but chances are they would have the same concerns about being your attorney as they would about being your executor. They would probably also expect to receive a fee similar to their usual professional fees. You should ask them about all this before naming them in your enduring power of attorney.

You can also name a trust company as your attorney. Trust companies prefer to talk to you before you sign your enduring power of attorney so they can tell you about the services they offer, how they prefer to invest your assets, and the fees they will charge. If you decide to appoint one as your attorney, the company likes to talk to the lawyer who is drafting the enduring power of attorney, and it may send him or her sample clauses to insert into the document to make the trust company's job clearer and easier. Your lawyer should review these with you before you sign the document to make sure you understand them and agree to them.

If you can't come to terms with a trust company, then you are sometimes able to appoint the public trustee of your province. Not all public trustees accept enduring power of attorney appointments. In New Brunswick, Alberta, and NWT/Nunavut, for example, they do not. In Ontario they do, but only if you get their written consent before you sign the document. No trustee in Yukon has ever been appointed, although the territory has no rules against it. The others do, but they always appreciate the chance to talk to you before you sign the document so that they can be sure it complies with their requirements and contains all the powers and provision they need to do the job properly. Check with your local office before you proceed. For contact details of the public trustee in your province, see Appendix 1.

If you don't know anyone you feel confident can handle your affairs, you can appoint two or more people and say they have to make all decisions unanimously.

In case the attorney you name dies or becomes incapacitated and can't do the job, your enduring power of attorney should name a backup attorney. Whomever you choose, your attorney's authority will have to be triggered, as discussed in the next section.

5. The Trigger, or *When Do I Want My Attorney to Start?*

The executor of your will knows exactly when his or her job starts — when you die. But how will your enduring power of attorney know when to step in? If you are lucky enough to be very close friends with a leading expert on loss of mental function, then you don't have to worry about this, but most of us aren't. How will your spouse, child, partner, best friend, accountant, or trust officer know when you have lost the capacity to make your own decisions? How comfortable will they be having to decide that you can't manage your money and assets anymore and they must take over? Not very. While some people do give this responsibility to the attorney, the enduring power of attorney documents I drafted always did one of the following:

- they designated someone to evaluate competence and trigger the enduring power of attorney, or

- they were effective when signed and were put away until needed.

A specific health care person who knows you, such as your family doctor, home care nurse, psychologist, or social worker is usually designated to evaluate your competence, but it could be anyone else. The key factor is that it is a person who won't take your money and run while you are still competent.

If you can't think of anyone, or if your family doctor happens to retire and move to Florida before you do, you can designate any two doctors who are familiar with your case.

Either way, the trigger event should be a note in writing, signed and dated by the designated person, and attached to the

enduring power of attorney. Otherwise, the outside world won't know if the enduring power of attorney is in effect or not.

The second approach may sound odd, but it works for people who have a long-standing relationship and share a deep-seated trust. It allows them to avoid the poking and prodding that goes along with a medical examination to establish competence. They simply appoint each other and then put the enduring power of attorney in a secure place, such as a safety deposit box, for future use. Both people need to be able to get into the box in an emergency for this to work, of course.

The trigger event should be a note in writing, signed and dated by the designated person, and attached to the enduring power of attorney.

6. The Attorney's Tool Box, or *What Does My Attorney Need in Order to Do the Best Job?*

This is where you give your attorney powers to handle as many of the potential occurrences related to your affairs (i.e., the "maybes") as you can. This could include power to —

- manage your personal financial affairs,
- manage and invest your assets,
- keep or invest your wealth in assets that may not be approved for trustees,
- deal with your real estate,
- pay for your maintenance and benefit,
- obtain professional assistance with managing your assets,
- continue making charitable donations and other gifts on your behalf,
- obtain originals of your important documents,
- dispose of your personal or household items,
- work with your health care agent to pay for the best possible care for you,
- pay themselves for their services as your attorney as and when you permit,

- report to your family or friends as you require, and

- keep proper records of their handling of your estate.

The sample enduring power of attorney at the end of this chapter gives you the complete wording of each of these powers.

As you read this list, you see that there are two big challenges for your enduring power of attorney:

- The challenge of long-term asset management

- The challenge of working with your health care agent

7. The Challenge of Long-Term Asset Management

Some of us have enough trouble looking after our own assets, let alone taking over the job of managing someone else's. Term deposits, GICs, Canada Savings Bonds, corporate bonds, mutual funds, rental properties, pork belly futures, the next Bre-X, the latest dot-com stock — the possibilities are endless and often mind-boggling. But at least we are free to do what we want, and if we goof up, we have no one to blame but ourselves.

The law of every province limits what investments an attorney can hold.

Unfortunately, an enduring power of attorney doesn't have the same unlimited scope. The law makes it clear that an enduring power of attorney will be held to the same standard as a formal trustee or any other fiduciary (the legal word for someone who is held to a very high standard of honesty and care when looking after the affairs of someone else). That means no Bre-X or dot-coms. But what if you already have such assets in your portfolio when your attorney takes over?

The law of every province limits what investments an attorney can hold. British Columbia and Alberta still publish a list of approved investments, which are always fairly conservative. But governments have more important things to do than review these lists all the time, so the lists get out of date. Right now, for example, it is not legal for an attorney to hold land or mutual funds. Technically, if you have a house and an RRSP that owns a

mutual fund, your attorney would have to sell both and invest in an approved investment as soon as he or she took over. This may not be what you want, and chances are your attorney won't even know this anyway.

Fortunately, the other provinces have discarded the list of approved investments and have set up another standard for fiduciaries like attorneys and trustees. It is called the standard of the reasonable investor or of the reasonable trustee. This eliminates a rush to sell investments regardless of market conditions, and also allows your attorney to use his or her judgment when buying assets for you. Make sure you give your attorney the scope he or she needs to deal with your investments in your enduring power of attorney document.

Every enduring power of attorney document should also give the attorney the power to get, and pay for, outside advice if necessary. You would turn to a professional for help if you needed it, so why can't your attorney?

> Make sure you give your attorney the scope he or she needs to deal with your investments in your enduring power of attorney document.

8. The Challenge of Working with Your Health Care Agent

Your health care agent is the person you appoint to handle your personal care and health care should you become incapacitated. Chapter 7 deals with the advance health care directive and health care agent in more detail.

The line between where an enduring power of attorney's power stops and a health care agent's power begins is not an easy one to draw as far as looking after your physical needs goes. Both are trying to make sure you get the best possible care, but from a different point of view.

Your health care agent decides where you should live and what you should get, while your attorney has to make sure your estate can afford to pay for it. Therefore, it is vital that these two decision-makers can work together. Of course, they can be the

same person, which at least eliminates some of the potential conflict, but that isn't always the best solution for everyone.

Try to give some thought to how these two people will work together, and don't be afraid to put something about this into your documents. I have yet to see it done, but why can't both documents say that if the attorney and the agent can't resolve their differences over something, then they have to go to a mediator or some other neutral third party to work it out? Don't leave them with no choice but going to court and having to use the money in your estate to settle their differences.

3.1 Enduring power of attorney

3.1.1 The set-up

Attorney

Name _____

Address _____

Phone number _____

Joint Attorney

Name _____

Address _____

Phone number _____

Alternate Attorney

Name _____

Address _____

Phone number _____

Compensation (yes, no)

Amount _____

3.1.2 The trigger (select one)

In force when signed ❏

In force on incapacity ❏

Evidenced by doctor's note

Name of doctor _____

Address _____

Phone number _____

Other triggering event (specify) _____

3.1.3 Attorney's tool box

General unrestricted power to manage affairs (yes, no)

Or, selected specific powers (check as required):

- ❏ Maintain spouse and children
- ❏ Manage or sell real estate
- ❏ Sign all necessary documents
- ❏ Enforce contracts
- ❏ Collect debts and benefits owing
- ❏ Mediate or arbitrate disputes
- ❏ Make gifts to family, church, charity
- ❏ Hire professionals to assist
- ❏ Expanded investment powers
- ❏ Right to obtain personal documents and information
- ❏ Power to store or dispose of household and personal items
- ❏ Assist health care agent in providing best affordable care
- ❏ Ratify attorney's decisions
- ❏ Establish standard of good faith

Specific restrictions or limitations: _____

ENDURING POWER OF ATTORNEY

ENDURING POWER OF ATTORNEY

I, *George Q. Willmaker* of *Anytown, Anyprovince,* state as follows:

1. **Cancel previous powers of attorney**

 I cancel any enduring power of attorney that I have already given.

2. **Appoint an attorney**

 a. I appoint my spouse, *Josephine Willmaker,* as my attorney in accordance with *Anyprovinces's* power of attorney law

 b. If *Josephine Willmaker* is unable or unwilling to act, then I appoint my son *Syd Willmaker* in her place.

 c. I confirm that *Josephine Willmaker* and *Syd Willmaker* are over the age of majority.

3. **Come into effect**

 This power of attorney will come into effect only if I become infirm or mentally incapable of making reasonable judgments about my property.

4. **Who may make the written declaration**

 a. A written declaration, in the attached form, from *Dr. Mydoctor,* medical doctor, now of *Anytown in Anyprovince,* will be conclusive proof that I have become infirm or mentally incapable.

 b. If *Dr. Mydoctor* is not available to determine whether I am infirm or mentally incapable, then any two medical doctors authorized to practice in *Anyprovince* may make the written declaration.

5. **Powers**

 a. General powers

 My attorney has authority to do anything on my behalf that I may lawfully do by an attorney, including but not limited to power to do the following:

 (i) To maintain, educate, benefit, and advance my spouse and children.

 (ii) To make gifts to charities in amounts similar to donations I may be in the habit of making.

 (iii) To make gifts to my spouse, children, and grandchildren on special occasions, including cash gifts. My attorney has absolute discretion concerning amounts.

 (iv) To make such investments as she considers reasonable without being limited to investments that are authorized for trustees.

(v) To provide for my maintenance, benefit, and welfare, and to pay any nursing or medical expenses that may be necessary, especially those that are not covered under provincial health care.

(vi) To retain such professional advice as she deems necessary.

(vii) To obtain any documents that belong to me as may be relevant to the management of my affairs.

(viii) To dispose of my personal or household goods as may be necessary as she sees fit.

b. Real estate powers

My attorney also has authority to sell, transfer, assign, lease, mortgage, or discharge any interest I may have in any real property. This includes power to execute all instruments and do all acts, matters, and things that may be necessary for:

(i) Carrying out the powers hereby given;

(ii) The recovery of all rents and sums of money that may become or are now due or owing to me in respect of the land;

(iii) The enforcement of all contracts, covenants, or conditions binding on any lessee or occupier of the land or on any other person in respect of it and for the taking and maintaining possession of the land and for protecting it from waste, damage, or trespass; and

(vi) Discharging or assigning any encumbrances.

6. **Restrictions on powers**

This power of attorney is subject to the following restrictions:

a. *My attorney may not use my property to benefit any charity or to educate my children outside Canada.*

b. *My attorney may not sell any of my real property.*

7. **Payment to attorney**

My attorney will be paid *$200 a month, which I consider to be fair and reasonable compensation,* for administering my estate.

8. **Resolution of disputes**

If any disputes should arise regarding the interpretation of this Enduring Power of Attorney, the decisions of my attorney, or any other matter connected with my financial affairs, I give my attorney power to retain the services of any competent mediator or arbitrator, as she sees fit. It is my intention that the costs of resolving any disputes be kept to an absolute minimum and that litigation be used only as a last resort.

DATED at *Anytown, Anyprovince*

This *9th of January, in 20-*

I.M. Witness

(Signature of Witness)

George Q. Willmaker

(Signature of *George Q. Willmaker*)

AFFIDAVIT OF EXECUTION FOR WITNESS

I, *I.M. Witness* of *Anytown, Anyprovince,* MAKE OATH AND SAY:

1. That I was personally present and did see *George Q. Willmaker,* who is personally known to me, duly sign the annexed Enduring Power of Attorney as maker and execute the same for the purposes named therein.

2. That I signed the Enduring Power of Attorney as witness in the presence of the donor.

3. That the Enduring Power of Attorney was executed at *Anytown, Anyprovince* and that I am the subscribing witness thereto.

4. That I know the said maker and he is in my belief of the full age of eighteen years.

5. That I believe that the attorney and alternate attorney named in the within instrument are of the full *age of majority* years.

I.M. Witness

(Signature of witness)

SWORN before me at *Anytown*
in the Province of *Anyprovince*
this *9th of January, 20-*

John C. Commissioner

A Commissioner for Oaths in and for
the Province of *Anyprovince**

* If the enduring power of attorney is likely to be needed outside your province or territory, then this affidavit should be completed by a notary public instead of a commissioner for oaths.

CERTIFICATE OF LEGAL ADVICE

I, *Fred D. Lawyer,* Barrister and Solicitor, practising in *Anytown in Anyprovince* do hereby certify that:

1. *George Q. Willmaker,* the maker of this Enduring Power of Attorney, attended before me on Thursday the *9th of January, 20-.*

2. He appeared to me to understand the nature and effect of the Enduring Power of Attorney.

3. I am satisfied that he was of the full age of *age of majority* years.

4. He signed the Enduring Power of Attorney in my presence.

5. He acknowledged to me that he was signing this Enduring Power of Attorney voluntarily.

6. I am not the Attorney named in the Enduring Power of Attorney nor the Attorney's spouse.

Signed at *Anytown, Anyprovince* this *9th of January, 20-.*

Fred D. Lawyer

Barrister and solicitor

DECLARATION OF MEDICAL DOCTOR

I, *Dr Mydoctor,* of *Anytown, Anyprovince* DECLARE THAT:

1. *George Q. Willmaker* is unable to make reasonable judgments about his property due to infirmity or mental incapacity.

2. I have formed my opinion based upon the following information, observations, and symptoms:

3. Diagnosis: _____

4. Prognosis: _____

5. I am a medical doctor authorized to practice in the province of *Anyprovince*

6. This declaration is made pursuant to paragraph_____of the Enduring Power of Attorney signed by *George Q. Willmaker* on the *9th January 20-.*

 Signed at *Anytown, Anyprovince,* this *15th day of March, 20-*

Sylvester Mydoctor, MD _Dr. Mydoctor_____
Print name Signature of doctor

Address _____

Phone_____

Fax_____

7

Your Advance Health Care Directive

When I worked for a trust company, we often had cases where we were appointed enduring power of attorney for an elderly person who had lost his or her spouse and never had any children. I detail one such case, that of an elderly woman, below. Let's call her Maxine.

Maxine had a lot of money but was alone. When Maxine's doctor sent the letter to the trust company saying she couldn't manage her money anymore, that triggered the enduring power of attorney and we took over. Unfortunately, Maxine didn't sign an advance health care directive when she signed the enduring power of attorney, so no one had legal power to make decisions about her health and personal care.

That didn't matter too much as long as she was living in her own home and was willing to let the home care workers in. Eventually, however, the time came for Maxine to go to a care facility. Unfortunately, Maxine didn't agree. A niece came forward to try to help and was thinking about getting a guardianship order, but when Maxine ran her off the property, the good-hearted niece changed her mind.

A short while after that, the local constabulary delivered Maxine to a psychiatric institute where she was held under the Mental Health Act as a person who was a danger to herself, and was

diagnosed and treated. She was stabilized, and the day came for her release. But where was she to go? Back to her house where the destructive cycle would begin all over again?

As the only people with any kind of legal authority over Maxine, the trust company was called to see if we would approve sending her to a suitable care facility. We explained that we only had authority to manage her money, not to make any decisions about her personal care, including where Maxine was to live. But the calls kept coming. Finally I said that while we couldn't approve placement in any particular facility, we did have power to pay the bills once a suitable facility was found and she was placed, as long as the bills were reasonable.

The next thing we knew, Maxine was happily residing in a brand-new private facility. She was getting the right level of care that she could easily afford, and we were paying the bills. So everything worked out for Maxine in the end, but things would have moved a lot smoother and faster with less stress and cost to the public if someone had had power to make decisions about her physical care when she was no longer able to do that herself.

To permit that, Maxine could have signed an advance health care directive, giving someone power to make decisions about her physical care. This chapter provides a summary of the issues surrounding advance health care directives. For more information, consult my book, *Your Personal Directive,* another title in the Self-Counsel Legal Series.

Advance health care directives (also know as personal directives) are commonly thought of as living wills; that is, documents for giving specific instructions about the kind of medical treatment you do or do not want to receive at the end of your life. They do that, but they also do something else that may be more important: they let you appoint someone to make sure your instructions are followed.

How many of you could write a list of everything you would want to happen if you were stricken by Alzheimer's tomorrow and were to live for another 10, 20, or even 30 years? What would

Advance health care directives let you appoint someone to make sure your instructions are followed.

you say about future medical breakthroughs, about changes in government policies on care for the aging, or about any other unexpected events that could affect your physical and mental well-being? Probably nothing, because you don't know what those things may be.

This brings us back to the realm of the "maybes," and back to the problem of how to plan for them. The answer is simple: Don't even try. Instead, appoint someone who knows you, and knows what you value and believe, to look after the maybes for you; someone you trust to make the choices for you that you would have made for yourself. Every province has its own name for that person (refer to Table 6 in Chapter 5), but for simplicity I will use the term health care agent.

Like the other two estate planning documents, the advance health care directive can be divided into parts (see Table 8). The advance health care directive, however, does one thing that the other estate planning documents don't do — it tells your agent what you want or do not want if you are at the end of your life because you are terminally ill. Once you have read through this chapter, you can begin to make these decisions for yourself using the Advance Health Care Directive Worksheet (Worksheet 4) as your guide.

> Your health care agent must be someone you trust to follow your wishes about your health care and personal care when you can no longer make those decisions yourself.

1. The Set-up, or *Who Will Be My Agent?*

Your health care agent must be someone you trust to follow your wishes about your health care and personal care when you can no longer make those decisions yourself. That implies that the person must know you very well, understand and respect your values and beliefs, and have the strength and courage to ensure that your wishes, values, and beliefs are respected and followed by the outside world. This may or may not be the same person you have already selected for the jobs of executor and attorney. The executor and attorney will handle your assets, but your health care agent will be making personal care decisions that may be very emotional.

TABLE 8
THE LOGICAL STRUCTURE OF AN ADVANCE HEALTH CARE DIRECTIVE

Part	What it does	Underlying question
The set-up	Appoints your surrogate financial decision-maker (health care agent) and backup	Who will be my agent?
The trigger	Establishes when you have lost capacity and how your agent knows when to take over	When do I want my agent to start?
End-of-life instructions	Tell your agent what end-of-life decisions to make if you are terminally ill	What do I want my agent to do if I am terminally ill?
The attorney's tool box	Gives your agent power and discretion to handle any potential occurrences related to your personal and health care (the "maybes")	What does my agent need in order to do the best job?

However, if you think back to the example of Maxine at the beginning of this chapter, you will remember that the line between estate management and personal care can be a grey one. The best advice is: Don't leave your loved ones to walk this line. Do all three documents, and even if you can't give them instructions on everything, you will have made it clear who has power to make which type of decision as issues come up.

The most likely candidates for the job of health care agent are spouses, adult children, or close friends, but some people call on clergy or other close advisors. Note that trust companies cannot

and will not do this. They are licensed to handle estates, but they do not have the expertise or the legal right to make decisions about personal or health care matters.

Some provinces have another public official, usually called the public guardian, who looks after the personal affairs of incapacitated adults when so ordered by the courts. These officials may be part of the public trustee's office (as in Ontario and Manitoba, for example) or they may be found in separate departments (as in Alberta, PEI, and NWT/Nunavut). If you do not do an advance health care directive, and there is no one to get a guardianship order to look after you, you may eventually come under the care of one of these officials. Also, these public guardians may or may not be willing to accept an appointment as your agent in an advance health care directive. If you are considering the public guardian option, the best advice is to contact them and ask. Your local public trustee can tell you if there is a public guardian in your province and how to reach them.

> You want to make sure no one could possibly abuse your advance health care directive by making personal care decisions for you when you don't need their help.

2. The Trigger, or *When Do I Want My Agent to Start?*

The trigger issues are also very similar to the ones we discussed when talking about the enduring power of attorney. You want to make sure no one could possibly abuse your advance health care directive by making personal care decisions for you when you don't need their help. This can be difficult to determine in many cases. There are many bitter lawsuits between children who don't agree that Mom or Dad has lost capacity to the point where one of them has to take over, and each side will have a medical expert who in good faith believes exactly the opposite of his or her colleague on the other side.

So who pulls the trigger? As we saw with enduring power of attorneys, many couples have sufficient trust to allow the other to make this tough call. Others go with their doctor or another

health care advisor. There is no perfect answer, so the best advice is to follow your instincts.

3. End-of-Life Instructions, or *What Do I Want My Agent to Do If I Am Terminally Ill?*

There are two approaches to the issue of end-of-life treatment instructions. You can give your agent —

- general statements based on level of consciousness, degree of suffering, chance of survival, or other quality of life factors, or

- specific treatment choices from a list or written by you, depending on your condition.

Either way, you are trying to be clear about what you do or do not want done to you to keep you alive when faced with a life-threatening illness.

Anything arising from your religious convictions, or anything you learned from an experience with a dying family member or friend can also be included here.

The end-of-life section of the advance health care directive can be very difficult to write for yourself, so the sample advance health care directive at the end of this chapter (see Sample 4) offers a series of choices you can consider. Select the one that makes most sense to you. Of course, you are free to make changes, or write your own if you wish.

Most people get to this part of the directive and quit. They just can't wrap their minds around end-of-life choices. I don't blame them, but if that is you, please don't quit. Instead, leave this section out altogether. Then, if these issues come up, your agent will make the best decision he or she can, based on his or her knowledge of your values and beliefs.

4. The Agent's Tool Box, or *What Does My Agent Need in Order to Do the Best Job?*

If you think of your agent's job in terms of a traditional living will (i.e., to deal only with end-of-life choices), and if your end-of-life instructions are as clear as you can make them, why do you need anything else? The answer lies in the fact that your advance health care directive is more than a living will — it is designed to give your agent legal power to handle all your personal and health care decisions if you can no longer do that yourself. For that reason I recommend including a list of powers like the powers that a judge can give under an adult-guardianship order. Those orders have been around for years; they cover most of the typical issues that can arise, and many people are used to dealing with them. These include power to —

- make normal health-related decisions, including:
 - obtaining needed treatment including medical and dental treatment;
 - authorizing admission to or discharge from a facility;
 - consenting to or refusing consent to surgery, medication, therapies, dietary matters, or exercise programmes;
 - reviewing medical records; and
 - signing documents;
- decide on accommodation and living arrangements, including with whom you will live and associate;
- decide on social and recreational activities, educational opportunities, and even employment, when relevant; and
- look after legal matters that involve your person (e.g., personal injury claims).

There are a number of other matters you might add, and I refer to these in the sample advance health care directive at the end of this chapter. You may want your agent to regularly consult with your friends or family members, or to keep a record of

Adult-guardianship orders have been around for years; they cover most of the typical issues that can arise, and many people are used to dealing with them.

their decisions. You may want your doctor to review your competence on a regular basis. If you are a woman, you may want to say something about what is to be done if you become incapacitated during pregnancy. You may even want to include a paragraph that deals with disputes: I have included a clause in the sample advance health care directive that directs the agent to try mediation before hiring a lawyer and going to court.

You will also see a clause in the sample advance health care directive that directs the agent to try to consult with you before making any major decisions. What better way for your agent to show that he or she has your best interests at heart than to ask you what you think? If you are incapacitated and can't communicate at all, no harm done. But if you could communicate — even by a blink of your eye — wouldn't you appreciate being asked?

The sample also contains a number of items I call administrative matters, such as —

- revoking prior advance health care directives,

- allowing fax copies or photocopies to be as valid as the signed original,

- nominating your advance health care directive agent as your guardian if there is a court battle,

- releasing from liability those who act on directions from your agent, and

- declaring that your advance health care directive is to be considered valid in any province where it is needed.

These statements may or may not be legal in every province, but they are a good idea, and they are strong evidence of your intention, which is what this is all about.

Finally, there may even be things you specifically do not want your agent to do, and those can go in, as well. If you are strongly opposed to being kept alive when you have no quality of life, for example, you may want to insert something here about that if you haven't already addressed it in the end-of-life section.

> There may even be things you specifically do not want your agent to do, and those can go in your advance health care directive as well.

5. The Most Important Person in Your Health Care Directive Is Your Agent

Once again, we see that the most important person in this estate planning document is not you; it is your agent, so pick a good one. All the comments on how to choose an executor and attorney apply here. But there is more. Because your agent will be dealing with very personal issues which can get quite emotional, it goes without saying that he or she should be comfortable with that kind of decision, and with dealing with all kinds of people. Those you have chosen as your asset managers may or may not be the best ones to select as your health care agent.

3.2. Advance health care directive

3.2.1 Set-up

Health care agent

Name _____

Address _____

Phone number _____

Joint health care agent

Name _____

Address _____

Phone number _____

Alternate health care agent

Name _____

Address _____

Phone number _____

Compensation and expenses to be paid (yes, no)

3.2.2 The trigger

Evidenced by doctor's note

One doctor or two (pick one)

Name of doctor(s) _____

Address _____

Phone number _____

3.2.3 Treatment instructions

Overriding duty to consult me (yes, no)

If I can communicate, what I say goes (yes, no)

If I can't communicate (select one or all)

 ❏ Follow instructions below

 ❏ If none, do what I would do myself

 ❏ If not known, do what is in my best interest

General treatment instructions:

 ❏ Receive all possible treatment

 ❏ Let my agent decide

 ❏ Instruction to withdraw or withhold specific treatments

 If permanently unconscious _____

 If unable to think or communicate_____

 ❏ If risks outweigh benefits _____

End of life treatment instructions:

Terminal condition (select as appropriate)

 ❏ Cardiac resuscitation

 ❏ Mechanical resuscitation

 ❏ Nutrition or hydration by tubes

 ❏ Blood or blood products

 ❏ Surgery or invasive tests

 ❏ Antibiotics

Permanently unconscious (select as appropriate)

 ❏ Cardiac resuscitation

 ❏ Mechanical resuscitation

 ❏ Nutrition or hydration by tubes

 ❏ Blood or blood products

 ❏ Surgery or invasive tests

 ❏ Antibiotics

Persistent vegetative condition (select as appropriate)

- ❏ Cardiac resuscitation

- ❏ Mechanical resuscitation

- ❏ Nutrition or hydration by tubes

- ❏ Blood or blood products

- ❏ Surgery or invasive tests

- ❏ Antibiotics

Additional instructions in own words (insert): _____

3.2.4 Agent's tool box (select as appropriate)

- ❏ Healthcare decisions

- ❏ Accommodation

- ❏ Companions

- ❏ Educational, social, recreational activities

- ❏ Legal matters relating to my person

- ❏ Report to specific people

- ❏ Keep record of decisions

- ❏ Pregnancy override

- ❏ Mediate or arbitrate disputes

Sample 4
ADVANCE HEALTH CARE DIRECTIVE

ADVANCE HEALTH CARE DIRECTIVE

This is the Advance Health Care Directive of *George Q. Willmaker* currently residing at *Anytown, Anyprovince.*

1. **Appointment of agent**

 a. I appoint my spouse, *Josephine Willmaker*, of *Anytown, Anyprovince*, as my agent to make personal and health care decisions on my behalf when I am no longer able to make or communicate my own health or personal care decisions due to lack of capacity.

 b. If she is unwilling or unable to act then I appoint my son, *Syd Willmaker*, of *Anytown, Anyprovince*, as my agent in her place.

2. **Coming into effect**

 a. This Directive will only be in effect if, and only as long as, I am unable to make or communicate my own decisions about my health or personal care due to lack of capacity.

 b. A declaration in the form of Schedule A completed by *Dr. Mydoctor* will be sufficient proof that I lack the capacity to make or communicate my own health or personal care decisions.

 c. If *Dr. Mydoctor* is unable or unwilling to make a determination about my capacity, or cannot be reached after every reasonable effort has been made, then the written declaration attached as Schedule B, signed by two physicians who are familiar with my circumstances, will suffice.

3. **Duty to consult**

 Before making any decision about my health or personal care, my agent must try to discuss it with me, even if the declarations described above have been completed.

4. **Basis for making decisions**

 a. If I am able to communicate in any way (including by gestures as well as by speaking or writing), then this Directive will have no effect.

 b. If I am unable to communicate:

 i. my agent is to follow my instructions as set out below,

 ii. if I have not left instructions on the issue at hand then my agent is to make for me the decisions I would have made for myself, based on my agent's knowledge of my wishes, values, and beliefs,

 iii. if my agent does not know what my wishes, beliefs, and values are with respect to a particular issue, then [he/she] is to make the decision that [he/she] believes is in my best interests under the circumstances.

5. **Power of agent**

 I give my agent power to make decisions about the following personal and health care matters:

 a. health care which includes, but is not limited to the following:

 i. to consent, refuse, or withdraw consent to any type of health care;

 ii. to review my medical records and consent to their disclosure to others;

 iii. to authorize my admission to or discharge from any medical or care facility;

 iv. to obtain health care services on my behalf;

 v. to hire or fire people to care for me;

 vi. to sign any waivers, releases, or permissions required by anyone who is providing health care service to me.

 b. accommodation/living arrangements:

 i. I wish to be allowed to live in my own home as long as reasonably possible

 c. with whom I may live and associate:

 i. I have no special wishes

 d. participation in social, educational, and employment activities:

 i. I wish to be allowed to participate in these areas as much as reasonably possible

 e. legal matters not relating to my estate:

 i. I know that my agent will attend to any such matters in a reasonable fashion.

6. **My instructions about end-of-life treatment**

 (initial only ONE of a, b, c, or d)

 a. No specific instructions

 I have chosen my agent because [he/she] is familiar with my wishes, beliefs, and values and I am confident that [he/she] will follow them. Therefore, I do not wish to include any specific instructions about end-of-life treatment.

 b. Instructions to withhold or withdraw treatment
 (if you initialled b, initial one of the following)

 I do not want my life prolonged if:

 _____treatment will leave me in a condition of permanent unconsciousness;

 _____treatment will leave me in a condition of limited consciousness and I will be unable to think or communicate with others;

 _____treatment will leave me with only some ability to think or communicate with others, and the risks associated with treatment outweigh the expected benefits. By risks, burdens, and benefits I mean factors like how much longer I might live, the quality of that remaining time, financial costs, and my dignity and privacy;

c. Instructions to receive treatment
I want my life to be prolonged as long as possible.

d. My instructions about end-of-life treatments

If I am suffering from a terminal condition, or become permanently unconscious, or am in a persistent vegetative state, I want only treatment that will keep me as comfortable and as free from pain as possible. In particular (check only those that apply to you; if you are aware of other specific treatment choices that are relevant to you, please add them to the list):

i. If I am in a terminal condition:

I do _____ I do not _____ want cardiac resuscitation
I do _____ I do not _____ want mechanical respiration
I do _____ I do not _____ want nutrition (food) or hydration (water) by tubes
I do _____ I do not _____ want blood or blood products
I do _____ I do not _____ want surgery or invasive tests
I do _____ I do not _____ want antibiotics

ii. If I am permanently unconscious:

I do _____ I do not _____ want cardiac resuscitation
I do _____ I do not _____ want mechanical respiration
I do _____ I do not _____ want nutrition (food) or hydration (water) by tubes
I do _____ I do not _____ want blood or blood products
I do _____ I do not _____ want surgery or invasive tests
I do _____ I do not _____ want antibiotics

iii. If I am in a persistent vegetative condition:

I do _____ I do not _____ want cardiac resuscitation
I do _____ I do not _____ want mechanical respiration
I do _____ I do not _____ want nutrition (food) or hydration (water) by tubes
I do _____ I do not _____ want blood or blood products
I do _____ I do not _____ want surgery or invasive tests
I do _____ I do not _____ want antibiotics

e. Additional instructions about end-of-life treatment in my own words:
I wish to be kept as comfortable and pain-free as reasonably possible.

7. **Responsibilities of agent**

a. report to relatives:

I instruct my agent to advise my family of my progress at reasonable intervals, especially those who live out of province.

b. keep records:

I wish that my agent keep a diary of my progress in case that information might someday be useful for research or other purposes.

c. consult with medical people:

I encourage my agent to consult with the appropriate medical professionals as and when [he/she] feels the need to do so.

8. **Pregnancy directions**

not applicable

9. **Administrative matters**

a. Revocation

I revoke any prior personal directives, advance health care directives, or living wills.

b. Validity

This Advance Health Care Directive is intended to be valid in any jurisdiction in which it is presented.

c. Copies

A photocopy or a fax copy of the signed original has the same effect as the signed original.

d. Release of liability

Anyone who relies on the instructions of my Agent or Alternate Agent and acts in good faith will not be liable to me or to my estate.

e. Nomination of guardian

If it becomes necessary to appoint a Guardian of my person under the appropriate law of the province, then I nominate my Agent as my first choice for Guardian, and my alternate as my second choice.

f. Resolution of Disputes

If any dispute arises about the interpretation of my wishes, about the validity of this Directive, or about any related matter, I encourage my Agent to pursue all reasonable ways to resolve it, including mediation, before resorting to litigation.

10. **Signature**

I confirm that I understand this document and the power it gives to my agent.

DATED at *Anytown, Anyprovince*, this *9th day of January, 20-*

George Q. Willmaker *D.M. Witness*

George Q. Willmaker WITNESS

AFFIDAVIT OF EXECUTION FOR WITNESS

I, *I.M.Witness* of *Anytown, Anyprovince*, MAKE OATH AND SAY:

1. I was personally present and did see *George Q. Willmaker* named in the within instrument, who is personally known to me to be the person named therein, duly sign and execute the same for the purposes named therein.

2. That the same was executed at *Anytown*, in *Anyprovince*, and that I am the subscribing witness thereto.

3. That I know the said *George Q. Willmaker* and he is in my belief of the full age of *age of majority.*

SWORN BEFORE ME at *Anytown*
in *Anyprovince, 9th day of January 20-*

I.M. Witness

Signature of witness

John C. Commissioner
Commissioner of Oaths
My Commission Expires ————

SCHEDULE A

Declaration of Incapacity by the Designated Person

Part 1:

I, *Dr. Mydoctor*, after consulting with the following physician or psychologist

Name ____*Dr. Otherdoctor*_____

Address _____*Anytown, Anyprovince*_____

Phone Number _____

regarding the capacity of *George Q. Willmaker*, declare that I am of the opinion that *George Q. Willmaker* lacks capacity to make decisions about the following:

_____ health care

_____ accommodation

_____ with whom to live and associate

_____ participation in social, educational, and employment activities

_____ legal matters not relating to his/her estate

__X__ all of the above

The reasons for my opinion are:

Signature of doctor____*Dr. Mydoctor*_____

Address of doctor_____*Anytown, Anyprovince*_____

Date _____*Anydate*_____

Part 2:

I, *Dr. The Otherdoctor*, confirm that I was consulted by *Dr. Mydoctor* regarding the capacity of *George Q. Willmaker*.

Signature of consulted doctor____*Dr. Otherdoctor*_____

Name of other doctor ____*Dr. Mydoctor*_____

Date _____*Anydate*_____

SCHEDULE B

Declaration of Incapacity by Two Service Providers

(To be used when person designated in the advance health care directive to complete Schedule A is not available.)

Part 1: To be completed by a physician or psychologist

I, *Dr. Otherdoctor*, of *Anytown, Anyprovince* declare that I am of the opinion that *George Q. Willmaker* is not competent to make decisions with respect to the following personal matters:

 _____ health care

 _____ accommodation

 _____ with whom to live and associate

 _____ participation in social, educational, and employment activities

 _____ legal matters not relating to his/her estate

 __X__ all of the above

The reasons for my opinion are:

Signature *Dr. Otherdoctor*

Address *Anytown, Anyprovince*

Date *Anydate*

Part 2: To be completed by other service provider

I, *Mr Other Serviceprovider*, am of the opinion that *George Q. Willmaker* is not competent to make decisions about the following:

 _____ health care

 _____ accommodation

 _____ with whom to live and associate

 _____ participation in social, educational, and employment activities

 _____ legal matters not relating to his/her estate

 __X__ all of the above

The reasons for my opinion are:

Signature of other service provider *Other Service Provider*

Address of other service provider_____*Anytown, Anyprovince*_____

Date _____*Anydate*_____

8

The Cost of Dying: Probate Fees and Income Tax

Two topics that always come up in any estate planning discussion, and that often also drive up people's blood pressure, are the cost of probate and income tax payable at death. Each of them deserves a book of its own, but in the interest of keeping everyone's blood pressure as low as possible, this chapter gives you some basic information to think about. For more information on probating an estate, see the *Probate Guide* for your province, published by Self-Counsel Press.

1. Probate Fees: "I Don't Want My Family to Pay Them"

1.1 What is probate?

The word "probate" comes from the Latin word for "proof." Getting probate is nothing more complicated than proving to a judge that the document that says it is somebody's last will really is. It is a routine legal procedure, so routine that the person applying for probate often doesn't have to appear in front of a judge. Instead, the paperwork is dropped off at the office of the probate clerk, and, if it is in order, the clerk gives it to a probate judge who reviews it, approves it, and signs a probate certificate. This certificate is proof to anyone who needs it that the will is the true

last will of the deceased, and that the person it names as executor has full legal power to take charge of the deceased's assets and distribute them as the will directs.

The names of the courts that deal with probate differ from province to province. Consult Table 9 to determine the name of the probate court and laws in your province.

TABLE 9
PROBATE COURTS AND LAWS BY PROVINCE

Province	Court	Law
British Columbia	Supreme Court	Supreme Court Rules
Alberta	Surrogate Court	Surrogate Court Rules
Saskatchewan	Queen's Bench	Queen's Bench Fees Act
Manitoba	Queen's Bench	Law Fees Act
Ontario	Superior Court of Justice	Administration of Justice Act
New Brunswick	Probate Court	Probate Court Act
Nova Scotia	Probate Court	Costs and Fees Act
Prince Edward Island	Supreme Court	Probate Act
Newfoundland	Supreme Court	Rules of the Supreme Court
Northwest Territories and Nunavut	Supreme Court	Probate Rules
Yukon	Supreme Court	Administration of Estates Act

Like executor anxiety, probate anxiety is another little understood psychological condition that was largely unknown in Canada before Ontario dramatically raised its probate fees several years ago. Probate anxiety is characterized by a deep-seated phobia about probate fees, and it is encouraged by an entire probate-avoidance industry that advises people to use any means possible to make sure their hard-earned assets aren't siphoned off in probate fees after they die.

1.2 Fees associated with probate

Three distinct fees are associated with the probate process — even for a routine estate. Strictly speaking, only one of them (the probate tax) is a probate fee, but the others are so closely connected with probate that they are usually lumped together. They are probate tax, lawyer's fees, and executor's fees.

1.2a Probate tax

Probate tax is the fee charged by the government for processing a probate application through the court.

These fees were previously not considered a tax until an astute woman took the Ontario government to court over them a few years ago. The case is called *Re Eurig,* and Mrs. Eurig argued that Ontario's probate fees didn't have anything to do with the amount of work involved in processing a probate application. In fact, she said, the fees really amounted to an illegal tax which the province had disguised as a courthouse processing fee.

She fought her case all the way to the Supreme Court of Canada, and won. But even though this enterprising woman got her fees back, no one else will — Ontario quickly passed a law making its probate fee a tax, and backdated it to cover every probate fee paid since the end of World War II. Every other province has done the same thing, and their probate fees are now legally a tax. Each province simply confirmed their existing rates, except Alberta, which dropped its rate back to where it was about 25 years ago.

> Probate tax is the fee charged by the government for processing a probate application through the court.

Alberta calculates its probate tax on the net value of the estate after debts are subtracted.

Table 10 shows the current probate tax rates across Canada, based on the total gross value of the estate. Note that Alberta calculates its probate tax on the net value of the estate after debts are subtracted. To get a practical idea of what these rates look like in a typical case, I have calculated the tax in each province on an estate of $500 000. The result is summarized in this table.

1.2b Legal fees

Legal fees are the fees charged by lawyers for the legal work involved in the probate application.

Many lawyers prepare the legal documents for a probate application and submit them to the court on behalf of the executor of the estate. The fee they charge for this service used to be set by the government, but this is no longer the case. Today, most lawyers charge by the hour for processing a probate application. However, some may do the work for a fixed fee if the case is routine and there aren't any problems that will complicate the file (such as lawsuits by beneficiaries). If the lawyer's fees seem unreasonable for the amount of work done, you can usually have them reviewed by an independent court officer. Contact your local court for more information.

Some provinces have suggested guidelines for legal fees, but many lawyers are willing to negotiate a fee that is less than the suggested amount. And, of course, if you have the time and energy to get probate without a lawyer, you won't have to pay any legal fees.

1.2c Executor's fees

Executor's fees are the fees payable to the executor for the work he or she does to get probate, and then to settle the estate once probate is issued (also referred to as administration fees).

The Trustee Act of each province and territory says that an executor can claim fair and reasonable compensation for his or her work administering an estate. If the amount claimed by an executor does not seem reasonable to the beneficiaries, then the amount must be reviewed and set by a judge of the appropriate

TABLE 10
PROBATE TAX RATES BY PROVINCE

Province or Territory	Total gross value of the estate	Probate tax rate	Probate tax on a $500 000 estate
British Columbia	Under $10 000 $10 001 and higher Plus if $25 000 to $50, 000 Plus for each $1 000 over $50 001	zero $208 $6 per $1 000 $14 per $1 000	$208 + (25 x $6) + (450 x $14) = **$6 658**
Alberta * Alberta calculates its probate tax on the net value of the estate after the debts are subtracted.	Under $10 000 $10 001 – $25 000 $25 001 – $50 000 $50 001 – $100 000 $100 001 – $250 000 $250 001 – $500 000 $500 001 – $1 000 000 Over $1 000 001	$25 $100 $200 $400 $600 $1 500 $3 000 $ 6 000	**$1 500**
Saskatchewan		$7 per $1 000	**$3 500**
Manitoba	Under $5 000 Plus for each $1 000 over $5 001	$25 $6 per $1 000	$25 + (495 x $6) = **$2 995**
Ontario	Up to first $50 000 Plus if over $50 001	$5 per $1 000 $15 per $1 000	(50 x $5) + (450 x $15) = **$7 000**
New Brunswick	Under $5 000 $5 001 – $10 000 $10 001 – $15 000 $15 001 – $20 000 Plus for each $1 000 over $20 001	$25 $50 $75 $100 $5 per $1 000	$100 + (480 x $5) = **$2 500**
Nova Scotia	Under $10 000 $10 001 – $25 000 $25 001 – $50 000 $50 001 – $100 000 $100 001 – $150 000 $150 001 – $200 000 Plus for each $1 000 over $200 001	$75 $150 $250 $500 $600 $800 $5 per $1 000	$800 + (300 x $5) = **$2 300**

TABLE 10 — Continued

Province or Territory	Total gross value of the estate	Probate tax rate	Probate tax on a $500 000 estate
Prince Edward Island	Under $10 000 $10 001 – $25 000 $25 001 – $50 000 $50 001 – $100 000 Plus for each $1 000 over $100 000	$50 $100 $200 $400 $4 per $1 000	$400 + (400 x $4) **= $2 000**
Newfoundland	Under $1 000 Plus for each $1 000 over $1 000	$80 $5 per $1 000	$80 + (499 x $5) **= $2 575**
Northwest Territories and Nunavut	Under $500 $501 – $1 000 Plus for each $1 000 over $1 001	$8 $15 $3 per $1 000	$15 + (499 x $3) **= $1 512**
Yukon	Under $10 000 $10 001 – $25 000 Plus for each $1 000 over $25 000	Zero $140 $6 per $1 000	$140 + (475 x $6) **= $2 990**

British Columbia and Prince Edward Island put a maximum limit on the amount an executor can claim for fees.

surrogate court. Please note that British Columbia and Prince Edward Island put a maximum limit on the amount an executor can claim for fees. The limit is 5 percent of the estate. This is in line with the amount generally accepted as a rule of thumb for executor's fees, which is 5 percent of the value of the estate, as long as the size of the estate and the amount of work done justify that amount.

If the estate includes setting up and running a trust, then the law allows the executor (or the trustee of the trust if a different person is given that responsibility) to take ongoing fees as follows:

- 2.5 percent of the yearly value of the trust assets and income
- 2.5 percent of the yearly value of the trust assets disbursed

- plus 0.4 percent of the yearly average market value of the trust assets as a fee for general care and management of the trust

Executor's fees must be approved by all the beneficiaries when the executor presents the final accounting before handing over the assets and closing the estate. If the beneficiaries agree with the accounting, they will sign a release allowing the executor to distribute the estate. If a beneficiary objects to the amount the executor is claiming, then they will either have to negotiate, or get the fees approved by a judge. No assets can be distributed until this matter is settled.

There are five factors that a court will look at to make sure that the amount taken for executor's fees is reasonable:

- The size of the estate

- The care and responsibility required of the executor

- The amount of time involved in settling the estate

- The skills and abilities of the executor

- The degree of success the executor has in settling the estate quickly, efficiently, and properly

When the executor is a close family member who is also receiving a share of the estate, he or she will often not claim an executor's fee for the work done in winding up the estate. However, if the estate is complicated — and whenever it is handled by a professional executor such as a trust company — executor's fees will be claimed and paid.

1.2d Other common estate administration costs

A number of other costs don't have anything to do with getting probate, but can come up in the administration of an estate. What they are depends on the assets involved and on how much the executor is willing or able to do himself or herself. For example, if a house must be sold, appraisal fees, realtor's commissions, registry fees, and legal fees for the transfer of title must be paid.

And almost every estate needs to file tax returns, which might involve fees payable to an accountant or a tax service.

1.3 Avoiding probate

There are many legitimate ways to structure your affairs to avoid probate. These are beyond the scope of this book and you should consult a lawyer or accountant for more details on this.

2. Income Tax and Death

Until 1972, Canada had a pay-a-percentage-to-the-government type of inheritance tax. This was abolished in 1972 and there is now no inheritance tax in Canada.

However, there most certainly are tax consequences of dying. Let's take a brief look at them. Taxation is a complex area, and you or your executor may need detailed, personalized assistance with tax questions from a qualified tax expert.

2.1 Income earned by you to date of death

Just because you die doesn't mean you get out of paying the tax you would have otherwise paid on the taxable income you received while you were still alive. Your executor has to file one last personal tax return for you to catch all your taxable income from January 1 to the date of your death. This is called the T1 terminal return. Your estate does get one break, however: your executor can claim the full calendar year's worth of tax credits for you, no matter when you died.

2.2 Income earned by your estate after death

While your executor is administering your estate, some of your assets are probably earning income. The government knows that and expects its share of tax. Your executor has two choices and he or she should do the calculations and see what is cheaper before

While your executor is administering your estate, some of your assets are probably earning income. The government knows that and expects its share of tax.

making a decision. (**Note:** estates are usually taxed at the same rate as the deceased.) The choices are:

- He or she can pass that income on to your beneficiaries and let them declare their share of it on their tax returns for the year of your death.

- He or she can file a separate return for your estate (called a T3) so that income can be taxed in, and paid out of, your estate. This T3 return covers any income that is not being passed on to beneficiaries from the date of your death to the date your executor winds up the estate.

Your executor must file a separate T3 estate return if one of your beneficiaries is a non-resident of Canada — someone who lives in the United States, for example.

2.3 Capital gains tax at death

When you die, Canada's tax law presumes that, just before death, you sold everything you owned for a fair price. This is called "fair market value." The tax law then looks at what you paid for your taxable capital assets and subtracts the difference. If those assets went up in value during the time you owned them, that is called a capital gain, and a percentage of that gain is added to your income for the year of your death and is subsequently taxed.

Dealing with capital gains tax at death is a lot simpler than most people think.

Dealing with capital gains tax at death is a lot simpler than most people think. For many Canadians it may not be relevant at all as the most common capital asset owned by Canadians is their family home, and it is exempt from capital gains tax.

Take, for example, the house Mary and Fred bought after the Second World War. They didn't pay much for it in today's terms, and they know it is worth a lot more if they sold it today. That is what makes the house a capital asset: its value increases over time. The increase in value is called the capital gain, but Mary and Fred won't see a penny of it until it is sold. While tax laws tax the capital gain of other assets, the government doesn't want

to penalize Mary and Fred for buying a home. So when they sell it, or when they die, the capital gain on it is not taxable.

However, if you own other capital assets that go up in value, you do pay capital gains tax when they sell those assets or when you die. Let's say that Mary and Fred also owned some shares in Bell Canada. When Fred and Mary die, Canadian tax law tells their executor to follow these three steps in order to determine whether capital gains tax is payable:

(a) Pretend that Fred and Mary sold the Bell Canada shares the second before they died. (This is called a "deemed disposition.")

(b) Determine whether that pretend sale price is higher than the price Fred and Mary paid for the shares when they bought them. (Any increase in price is the capital gain.)

(c) If it is, then add a percentage of that gain to their final T1 terminal returns as income for that year. (This percent is called the inclusion rate, and is currently 75 percent.)

Commonly owned assets that can trigger a capital gain at death include mutual finds, vacation homes, and non-residential real estate.

Other commonly owned assets that can trigger a capital gain at death include mutual finds, vacation homes, and non-residential real estate. Cash assets, like term deposits, bank accounts, Canada Savings Bonds, and GICs, are not capital assets because they do not go up in value over time. Instead, they generate income which is declared and taxed every year.

2.4 Clearance certificate

No discussion of taxes and death is complete without reference to a clearance certificate. A clearance certificate is a letter from Customs and Revenue Canada to your executor saying that the government is satisfied that all taxes owing by you or your estate have been properly declared and paid, and the executor may distribute your assets as your will directs.

Every executor wants to know that the government is happy. No executor wants to discover two or three years down the line that there are unpaid taxes owing by the deceased or his or her

estate. By then the beneficiaries may have spent their money, and the executor could be dipping into his or her own pocket to cover the shortfall.

Unfortunately, it often takes a while for Customs and Revenue Canada to issue clearance certificates. So, once all the tax returns have been prepared and filed, it is common for executors to pay the beneficiaries a portion of their gifts and to hold back the rest until the certificate arrives. Usually, the executor will keep aside double or triple the amount of tax owing as well as any other unpaid amounts such as the executor's fee, just in case Customs and Revenue Canada disputes the calculations and more money is owed.

Tax matters can be confusing at the best of times and especially so where estates and trusts are concerned. The best advice is to get good professional advice from a tax specialist such as a lawyer, accountant, or trust officer. If you don't know any, you can find them using the approach I outline in the next chapter.

The best advice is to get good professional advice from a tax specialist such as a lawyer, accountant, or trust officer.

9

Finding and Using a Good Estate-Planning Lawyer

1. The Risks of Doing It Yourself

There is no law that says you have to use a lawyer when you create your estate planning documents. You are free to do any legal documents yourself, and during my 20 years in practice I saw — and successfully probated — a number of do-it-yourself wills. Now and then we had trouble carrying out the instructions. Sometimes the wills were so confused that the executor had to spend the estate's money getting a judge to decide which of the various possibilities the deceased had in mind, and occasionally the deceased didn't say what was to happen if cousin John died first — but we got probate.

The do-it-yourself approach can work in some situations, but even the so-called "simple will" can go dangerously wrong without input from a lawyer. When you do any legal document yourself you are taking some risks, but as long as you still have full capacity, you can fix most problems if they arise. Unfortunately, estate planning documents carry a different risk — the risk that you won't be able to fix any problems because by the time they come up you may not have mental capacity anymore, or you may be dead.

The best way I can think of illustrating the risks of doing your own estate planning documents is to tell you about the advantages and disadvantages of using a lawyer. As you review them, ask yourself if you are comfortable looking after each item yourself. If you are, you are a bona fide do-it-yourselfer and should carry on. If not, then the rest of this chapter outlines how to find a good estate-planning lawyer to help you.

2. Advantages of using a Lawyer

2.1 The "proof you had your marbles" factor

Getting a lawyer to prepare and witness your estate planning documents, especially if you found the lawyer yourself and met with him or her alone, goes a long way toward establishing the fact that you had full mental capacity when you signed those documents. If you or the lawyer are worried that someone might question that in the future, the lawyer can get a letter from your doctor right away, just in case.

Getting a lawyer to prepare and witness your estate planning documents goes a long way toward establishing the fact that you had full mental capacity when you signed those documents.

2.2 The "complete advice" factor

A good estate-planning lawyer can give you good local advice on every aspect of your estate plan, and will explain the various documents and how they interrelate. He or she can even give you good information on background issues, such as the different levels of care available in your community and how the public trustee and guardian work in your province. A good lawyer will have contacts with trust companies, accountants, insurance agencies, brokerage houses, and many other professionals working in the expanding elder care market.

2.3 The "multi-generational thinking" factor

A good estate-planning lawyer will automatically think beyond you and your spouse or companion and ask the "what if" questions that you may not ask yourself: What if your spouse dies before you do? What if your daughter gets married, has children

and gets hit by a bus before you die? What if your son gets divorced? What if one of your grandchildren is handicapped?

2.4 The "who pays if I make a mistake?" factor

If you make a mistake on an estate planning document yourself, you will have to fix it. If the mistake is found after you are dead, your executor and heirs will have to deal with it. But if you hired and relied on a lawyer, and that lawyer made an error, you or your executor should be able to make a claim against that lawyer's malpractice insurance. If the mistake was due to his or her negligence, your estate should recover the loss.

2.5 The "loss leader" factor

For years many lawyers have treated wills as a loss leader. They would do the will for less than their own cost in the hope that the client would bring in more lucrative business, and that the executor would bring in the estate work after the client died. This attitude still exists in many law practices, so you may get first-class estate planning help for a very reasonable fee.

2.6 The "legal boiler plate" factor

All lawyers have standard clauses that they include as a matter of routine in every estate planning document. Admittedly, the language used in some of those clauses can be intimidating and difficult to understand, but they often discuss important issues that you might otherwise not think about if you were doing your will without a lawyer.

2.7 The "personal comfort" factor

Most lawyers are in business to solve your problems, not to make them worse. Using a good estate-planning lawyer will go a long way toward giving you the peace of mind that comes from getting a difficult job done well and thoroughly.

Using a good estate-planning lawyer will go a long way toward giving you the peace of mind that comes from getting a difficult job done well and thoroughly.

2.8 The "future estate work" factor

If you have found a good estate-planning lawyer to do your documents, you have also found a good lawyer to help your family when those documents are triggered. This can be a source of comfort during what is already a stressful time for your family.

If you have found a good estate-planning lawyer to do your documents, you have also found a good lawyer to help your family when those documents are triggered.

3. All Lawyers Are Not Created Equal

For several years when I taught the Alberta Bar admission course on wills, I always began by asking the students, all of whom had law degrees, how many had taken a course on wills at law school. Year after year it never failed — only about half put up their hands. Although the wills course is strongly recommended for anyone going into private practice, it is not compulsory at all law schools.

Most people assume that any lawyer can do a will, and indeed any lawyer can. So people get the lawyer who did their house purchase or their daughter's divorce to do their estate planning documents. In most cases this works out well, but it's a little like seeing a chiropractor for a heart condition. Many lawyers today are specializing in the area I call the law of aging, and you can be sure that they are up-to-date in the issues surrounding estate planning. Whether you choose to go with a lawyer who has done other legal work for you, or with one that specializes in estate planning, the next section tells you how to be sure the lawyer you choose knows what estate planning is all about.

4. Three Steps to Finding a Good Estate-Planning Lawyer

As in any profession, there are bad lawyers out there, and finding a good estate-planning lawyer will help make the process less painful. A lawyer could be smart and competent, but if he or she (and his or her staff) has no people skills, you could be caught in a nightmare of no phone calls or letters, sloppy drafting, forgotten appointments, and unreadable documents.

A good lawyer will also be upfront about fees. All the surveys I've seen on what people don't like about lawyers put fees right near the top — not high fees, but lack of discussion in advance about fees. It's as if some lawyers think the right way to get paid is to present a bill the way they do the Academy Awards: lots of stomach churning suspense, a drum roll, and "The envelope please." If you end up with a lawyer who does that, you haven't followed the three-steps to finding a good estate-planning lawyer outlined below.

A good lawyer will be upfront about fees.

4.1 Step 1: Get the names of five good lawyers

"Wait a minute!" you say. "That's my problem. I don't know even one good lawyer!" That may be true now, but you are never more than a few phone calls (or maybe even mouse clicks) away from connections with people who deal with lawyers. Those connections fall into two basic groups: public and personal. All you have to do is make a list of your connections. Here's a list to get you started:

Public connections:

- seniors' organization
- Yellow Pages
- lawyers' ads
- lawyer referral services (free ones only)
- court staff
- public trustee staff
- law school professors
- better business bureau

Personal connections:

- clergy
- friends from church/synagogue/mosque
- doctor
- psychologist

- social worker
- public health nurse
- neighbours
- parents at your children's school
- mechanic
- corner store operator
- landlord
- people you volunteer with
- people in your night school class

Easy, isn't it? And once you get going you will think of many more.

After you've made a list of people you know who have dealt with lawyers, you need to talk to them. Phone the public connections. Be direct so you don't waste their time, and yours. Ask if they can recommend any good lawyers for estate planning documents. If they have a policy against that, ask if they can refer you to anyone who can make a recommendation. Then move on.

Talk to your personal connections. Ask them if they have used any lawyers recently. Was it for estate planning documents or something else? How did it go? Would they recommend him or her? Get names and phone numbers of the lawyers. Keep going until you have five to ten recommended lawyers.

4.2 Step 2: Use the phone

Once you have your list of five to ten potential candidates, start phoning. Start with the ones you already have a good feeling about. Be ready to speak to a live person — the receptionist — who will most likely tell you the lawyer is not available right now but you can leave a message on his or her voice mail. Don't be put off by this: it's true. The days when you were automatically put through to a lawyer are over, and almost everyone uses technology to manage their time and phone calls. So be ready

with a short message for the voice mail. Say you are looking for a lawyer to do your estate planning documents and ask the lawyer to call you back as soon as possible. Then move on to the next lawyer on your list.

When the lawyer calls back, do some quick weeding. Ask —

- if they do this work;

- if it is a big part of their practice or just a sideline;

- if they attend the Canadian Bar Association's monthly section meetings on wills and estates, or keep up-to-date in another way; and

- if they charge on an hourly basis or have a fixed fee.

The answers to these questions will tell you if the lawyer is focussed on estate planning, or if it is one of a multitude of areas he or she works in. They will also give you a first impression of the person on the other end of the phone, which will go a long way toward telling you whether or not you want to work with this person. The very best answers you are likely to get are —

- "Yes, I do that,"

- "A lot of that,"

- "Yes I keep up with current developments in the area," and

- "That depends."

Don't be upset if the lawyer seems to duck and weave a little on fees. Lawyers are conditioned by years of practice to charge on the basis of the amount of time put in, and they know that first-time clients always underestimate the amount of effort that goes into proper estate planning. That won't be a problem for you because you have read this book, but the lawyer doesn't know that.

In fact, just as you will be listening for certain key words from the lawyer, so will the lawyer be listening for certain key words from you, the most common being, "I just want a simple will."

> Lawyers are conditioned by years of practice to charge on the basis of the amount of time put in, and they know that first-time clients always underestimate the amount of effort that goes into proper estate planning.

Don't be surprised if that triggers a quick lecture on the realities of estate planning that ends with, "...and in my experience, there really is no such thing as a simple will," or, "...so we may end up with a simple will, but there are a lot of complex issues we have to deal with before we are sure a simple will is the right will for you."

Now make a quick decision. Do you have a good feeling about this person or not? If you do, set up an appointment, and make sure there will be no charge for the first office visit. If you don't like something about how the lawyer talks to you, or if you are uncomfortable with an initial fee, say thanks, hang up, and call the next lawyer on your list until you have two or three office appointments lined up.

If you don't like something about how the lawyer talks to you, or if you are uncomfortable with an initial fee, say thanks, hang up, and call the next lawyer on your list.

4.3 Step 3: Visit the prospects

When you go to see the two or three prospects you have selected, keep your eyes open. You can learn so much about the person you might be working with just by looking around the waiting room. Is the reception area neat and tidy? Does someone speak to you or are you left on your own? How long is the wait? Is there any estate planning or elder law information on display? Brochures? Magazines? Articles? What about samples of the work they do? Is there a sample will, enduring power of attorney, or advance health care directive in a binder for you to look over? Are their business cards crisp or tattered, dull or interesting?

When you are seated in the lawyer's office what do you see? Desk and cabinets piled high with files? Boxes labelled "Confidential — Jones Accident" in the corners? Or is it tidy and organized? Does the lawyer take an obvious interest in your needs, or does he or she launch into a speech using jargon and language you don't understand? Do you get the feeling the lawyer is watching the clock, or does he or she give you enough time to tell your story and ask questions? Are your questions answered to your satisfaction? Is the basis for charging the fee made clear?

You may want to make notes during this visit so you don't have to rely entirely on your memory later. When the meeting is

over, tell the lawyer that you are meeting with some other lawyers and you hope to make your choice as soon as you can. As a lawyer, I always made notes during these sessions and kept them in a file labelled "potential new clients." If I didn't hear back in a couple of weeks, I would throw them out. You may want to say that if you decide to go with that lawyer you will call, otherwise he or she can assume you went somewhere else.

If you didn't find a lawyer you could work with the first time, don't give up.

After visiting two or three lawyers, you should have a pretty good idea if you can work with any one of them. If so, pick one, call, and make the next appointment. Then, control the passage of time. I blush to say it, but I know from experience that legal work has a way of expanding to fill the time available. To prevent that I always tried to give clients a fixed date when they would hear from me next and write it down. If I couldn't make it, I tried to phone them before the deadline to explain why and set a new one. People don't like delay, but they vastly prefer to find out about it ahead of time rather than have a deadline go by and then wait, and wait, and wait to hear something.

If you didn't find a lawyer you could work with the first time, don't give up. Go back to Step 1 and repeat the process. With some careful selection you'll find the right person to help you plan your estate.

10
Getting Started

In this short book I have tried to demystify the highly technical area of law known as estate planning so you can understand the basics that apply to every Canadian, no matter what his or her personal circumstances may be.

I followed the natural approach to estate planning that my clients taught me, rather than trying to impose the academic approach I was taught, which — in my experience — did not help my clients get the job done. My goal was to stimulate you to make the basic decisions that everyone has to make.

In the Appendix you will find a blank copy of the entire three-step estate planning worksheet that I developed and refined during my 20 years in private law practice. Use this worksheet to help you get organized and stay organized. I hope it saves you from ever having to start estate planning from scratch again. The worksheet will also give your executor valuable clues if, or when, tragedy strikes and he or she has to step in and take over management of your personal or financial affairs.

These suggestions for planning your estate are one lawyer's version of doing so, and are not fool-proof, guaranteed precedents. Do not follow them blindly. It is not within the scope of this book to give you a form that complies with all the requirements of the law in every province.

What the samples in this book can do is show you how the different parts of each document might look, and how they fit together in a harmonious whole. Studying them should give you some ideas for your own documents, and you are free to discuss them with your local estate planning lawyer and adapt them for your use if you wish.

This book cannot anticipate all your unique needs and circumstances, and it is no substitute for good, thorough advice from a competent professional that you know and trust. They may be hard to find, but they exist, and thanks to this book you know how to go about it.

Having reached the important stage of completing your estate planning documents, don't put these documents away and forget about them. Your life will change, and my clients taught me that the most natural, logical time to review estate planning documents is whenever a major life-changing event occurs.

Finally, the law will change. A book like this can't possibly teach you everything you will ever need to know about this complex and evolving area of the law. That's another reason why you want to find a good estate-planning lawyer — to keep you informed of changes in the law that affect your estate plan.

Good luck!

Appendix 1
Contact Information for the Public Trustee

British Columbia
Public Trustee
808 West Hastings Street, Suite 700
Vancouver, BC V6C 3L3
Ph: (604) 660-4444
Fax: (604) 660-0374

Alberta
Public Trustee
4th Floor, J.E. Brownlee Building
10365-97 Street
Edmonton, AB T5J 3Z8
Ph: (780) 427-2744
Fax: (780) 422-1936

Saskatchewan
Public Trustee
6th Floor
1874 Scarth Street
Regina, SK S4P 3V7
Ph: (306) 787-5424
Fax : (306) 787-5065

Manitoba
Public Trustee
13th Floor
405 Broadway Avenue
Winnipeg, MB R3C 3L6
Ph: (204) 945-2700
Fax: (204) 948-2251

Ontario
Public Guardian and Trustee
800, 595 Bay Street
Toronto, ON M5G 2M6
Ph: (416) 314-2800
Fax: (416) 314-2698

New Brunswick
Administrator of Estates
Box 5100
3rd Floor
520 King Street
Fredericton, NB E3B 5G8
Ph: (506) 453-2737
Fax: (506) 463-2958

Nova Scotia
Public Trustee
201, 5151 Terminal Road
Box 685
Halifax, NS B3M 3Y9
Ph: (902) 424-7760
Fax: (902) 424-0252

Prince Edward Island
Public Trustee
Box 2000
Charlottetown, PE C1A 7N8
Ph: (902) 368-4561
Fax: (902) 368-5283

Newfoundland
Public Trustee
Box 7158
St. John's, NF A1E 3Y4
Ph: (709) 729-0850
Fax: (709) 729-3063

Yukon
Public Administrator
Box 2703
Whitehorse, YK Y1A 2C6
Ph: (867) 667-5366
Fax: (867) 393-6245

Northwest Territories
Public Trustee
Box 1320
Yellowknife, NT X1A 2L9
Ph: (867) 873-7464
Fax: (867) 873-0184

Nunavut
Public Trustee
Box 1000
Stn 560
Iqaluit, NU X0A 0H0
Ph: (867) 979-6000

Appendix 2
Three-Step
Estate Planner

Step 1: Getting Ready
1.1 Personal information

Full legal name _____

 Home address with postal code _____

 Phone with area code _____

 Fax _____

 E-mail _____

 Social Insurance Number _____

Employer _____

 Address _____

 Phone _____

 Fax _____

 E-mail _____

Your date and place of birth _____

Citizenship _____

Date and place of marriage(s) _____

Date and place of divorce(s)_____

Maintenance obligations_____

Name of current spouse (including common law spouse) _____

Does spouse suffer from disabilities or handicaps?_____

If so, details_____

Children (by spouse or otherwise) _____

 Names _____

 Dates of birth _____

 Are they married? _____

 Do they have children?_____

 Names _____

 Dates of birth _____

 Do any suffer from handicaps or disabilities? _____

 If so, details _____

Professional advisors (name, address, phone, fax, e-mail for each)

Lawyer _____

Accountant _____

Financial planner _____

Insurance agent _____

Clergy_____

Doctor _____

Last tax return filed

 Year _____

 Prepared by_____

1.2 Asset information

1.2.1 Probate-free assets

Joint assets with right of survivorship:

 Joint real estate:

 Name of co-owner _____

 Address _____

 Legal description _____

 Type: (check these as appropriate)

 ❏ House

 ❏ Cottage

 ❏ Farm

 ❏ Condo

 ❏ Acreage

 ❏ Rental property

 ❏ Commercial property

 ❏ Leases (apartment, office, mineral rights)

 ❏ Bare, undeveloped land

Joint cash assets:

Co-owner _____

Financial institution _____

Address _____

Account number _____

Location of papers _____

Type (check as appropriate):

 ❏ Joint bank accounts

 ❏ Canada savings bonds

 ❏ Term deposits

 ❏ Guaranteed income certificates

Other joint investments:

Stocks or shares

Co-owner _____

Issuing company _____

Location of certificate _____

Mutual funds

Co-owner _____

Issuing company _____

Who to contact _____

Designated beneficiary assets (name, address, phone number of beneficiary):

Life insurance products:

Life insurance policy

Company _____

Policy number _____

Location of papers _____

Name of beneficiary _____

 Address _____

 Phone number _____

Segregated mutual funds:

 Account number _____

 Contact info _____

 Name of beneficiary _____

 Address _____

 Phone number _____

Registered plans:

 Registered Retirement Savings Plan (RRSP)

 Financial institution _____

 Plan number _____

 Name of beneficiary _____

 Address _____

 Phone number _____

 Registered Retirement Income Fund (RRIF)

 Financial institution _____

 Plan number _____

 Name of beneficiary _____

 Address _____

 Phone number _____

Locked-in Retirement Account (LIRA)

Financial institution _____

Account _____

Name of beneficiary_____

Address _____

Phone number_____

Employment pensions:

Employer _____

Plan administrator _____

Address_____

Phone number _____

1.2.2 All the rest (sole ownership assets)

Real estate:

Address_____

Legal description_____

Check as appropriate:

- ❏ House
- ❏ Cottage
- ❏ Farm
- ❏ Condo
- ❏ Acreage
- ❏ Rental property
- ❏ Commercial property
- ❏ Lease (apartment, office, mineral rights)
- ❏ Bare, undeveloped land

Cash accounts:

Account number _____

Financial institution _____

Branch address _____

Branch phone number _____

Investments:

Financial institution _____

Account number _____

Personal property of value:

Vehicles

Make, model, year _____

Collections (itemize) _____

Tools (itemize) _____

Family heirlooms or other items of unusual emotional value:_____

Debts owing by family members (details):_____

By others (details)_____

Location of important papers:

Safety deposit box

Financial institution_____

Branch address_____

Location of key_____

Debts outstanding:

Mortgage

Financial institution_____

Branch _____

Line of credit:

 Financial institution _____

 Branch _____

Credit cards:

 Issued by _____

 Account number_____

Bank loans:

 Financial institution_____

 Branch _____

 Other (give details): _____

Step 2: Will
2.1 The set-up

Sole executor:

 Name _____

 Address _____

 Phone number _____

Joint executor:

 Name _____

 Address _____

 Phone number _____

Alternate executor:

 Name _____

 Address _____

 Phone number _____

Compensation for executor (yes/no)

 In addition to other gifts (yes/no)

 Guardian of minor children:

 Name _____

 Address _____

 Phone number _____

 Joint guardian:

 Name _____

 Address _____

 Phone number _____

 Alternate guardian:

 Name _____

 Address _____

 Phone number _____

 Financial assistance to raise children (yes/no)

 Survivorship clause (if mirror wills) (yes/no)

2.2 Who gets what, when

Beneficiaries:

 Names _____

 Dates of birth _____

 Addresses _____

 Phone numbers _____

Typical multi-generational distribution:

All to spouse (yes, no)

If no spouse to children (yes, no)

If child not alive to his/her children (yes, no)

Immediate gifts:

To whom? _____

Amounts:

Percentage _____

Fixed dollar amount_____

Specific assets (identify precisely)

If asset not owned at death? (Check one)

❑ Ignore gift

❑ Replace asset

❑ Give cash in lieu

Is there a trust?

Terms of trust:

Qualifying age _____

Compensation for trustee_____

Death before reaching qualifying age?

Family wipeout clause (i.e., if no spouse, children, or grandchildren):

To parents _____

To charities _____

Other _____

2.3 Executor's tool box (all yes/no)

	Yes	No
Exercise property rights	❑	❑
Realize and sell assets	❑	❑
Receipt for payments for minor beneficiaries	❑	❑

	Yes	No
Distribute assets in kind	❏	❏
Expand scope of investments	❏	❏
Make tax elections	❏	❏
Employ agents to administer estate	❏	❏
Apportion funds received	❏	❏
Encroach on capital	❏	❏
Mediate or arbitrate disputes	❏	❏
Borrow money	❏	❏
Manage real estate	❏	❏
Manage corporate or business assets	❏	❏
Renew personal guarantees	❏	❏

Other (specify) _____

Step 3: Enduring Power of Attorney and Advance Health Care Directive

3.1 Enduring power of attorney

3.1.1 The set-up

Attorney:

Name_____

Address_____

Phone number _____

Joint attorney:

Name_____

Address_____

Phone number _____

Alternate attorney:

Name_____

Address_____

Phone number _____

Compensation (yes, no):

Amount_____

3.1.2 The trigger (select one)

In force when signed ❑

In force on incapacity ❑

Evidenced by doctor's note

Name of doctor_____

Address _____

Phone number _____

Other triggering event (specify): _____

3.1.3 Attorney's tool box

General unrestricted power to manage affairs (yes, no)

Or, selected specific powers (check as required):

- ❑ Maintain spouse and children
- ❑ Manage or sell real estate
- ❑ Sign all necessary documents
- ❑ Enforce contracts
- ❑ Collect debts and benefits owing
- ❑ Mediate or arbitrate disputes
- ❑ Make gifts to family, church, charity
- ❑ Hire professionals to assist

❏ Expanded investment powers
❏ Right to obtain personal documents and information
❏ Power to store or dispose of household and personal items
❏ Assist health care agent to provide best affordable care
❏ Ratify attorney's decisions
❏ Establish standard of good faith

Specific restrictions or limitations _____

Advance Health Care Directive

3.2. Advance health care directive

3.2.1 Set-up

Health care agent:

Name_____

Address_____

Phone number _____

Joint health care agent:

Name_____

Address_____

Phone number _____

Alternate health care agent:

Name_____

Address_____

Phone number _____

Compensation and expenses to be paid (yes, no)

3.2.2 The trigger

Evidenced by doctor's note:

> One doctor or two (pick one)
>
> Name of doctor(s) _____
>
> Address_____
>
> _____
>
> Phone number _____

3.2.3 Treatment instructions

Overriding duty to consult me (yes, no)

> If I can communicate, what I say goes (yes, no)
>
> If I can't communicate (select one or all)
>
> > ❑ Follow instructions below
> >
> > ❑ If none, do what I would do myself
> >
> > ❑ If not known, do what is in my best interest

General treatment instructions:

> ❑ Receive all possible treatment
>
> ❑ Let my agent decide
>
> ❑ Instruction to withdraw or withhold specific treatments
>
> > If permanently unconscious_____
> >
> > If unable to think or communicate _____

❑ If risks outweigh benefits_____

End of life treatment instructions:

> Terminal condition (select as appropriate)
>
> > ❑ Cardiac resuscitation
> >
> > ❑ Mechanical resuscitation
> >
> > ❑ Nutrition or hydration by tubes
> >
> > ❑ Blood or blood products
> >
> > ❑ Surgery or invasive tests
> >
> > ❑ Antibiotics

Permanently unconscious (select as appropriate):

- ❏ Cardiac resuscitation
- ❏ Mechanical resuscitation
- ❏ Nutrition or hydration by tubes
- ❏ Blood or blood products
- ❏ Surgery or invasive tests
- ❏ Antibiotics

Persistent vegetative condition (select as appropriate):

- ❏ Cardiac resuscitation
- ❏ Mechanical resuscitation
- ❏ Nutrition or hydration by tubes
- ❏ Blood or blood products
- ❏ Surgery or invasive tests
- ❏ Antibiotics

Additional instructions in own words (insert): _____

3.2.4 Agent's tool box (select as appropriate)

- ❏ Healthcare decisions
- ❏ Accommodation
- ❏ Companions
- ❏ Educational, social, recreational activities
- ❏ Legal matters relating to my person
- ❏ Report to specific people
- ❏ Keep record of decisions
- ❏ Pregnancy override
- ❏ Mediate or arbitrate disputes

Glossary

advance health care directive	a document that appoints someone to physical and health care decisions for its maker if the maker is unable to make such decisions due to mental or physical disability; also called **personal directive**
attorney	a person or persons named in an enduring power of attorney to look after the assets and financial affairs of the maker
beneficiary	those named in a will to receive the assets of the testator after all debts and proper expenses are paid; also those named in a trust to receive the benefit of the trust assets
clearance certificate	a certificate from the Canada Customs and Revenue Agency confirming that all tax owing by the estate has been paid
codicil	a written change to part of a will that is not intended to cancel the whole will
enduring power of attorney	a power of attorney that continues in effect after its maker loses mental capacity

executor	the person or persons named in a will to carry out the instructions in that will
executor's year	the time assumed to be reasonable for an executor to finalize a typical estate
executrix	the female version of the word "executor;" it is becoming less common as the word executor is now being used for both males and females
guardian	a person or persons appointed by court order to make health and physical care decisions for an adult who is unable to do so due to mental or physical disability
heir	in plain language, the same as **beneficiary;** the technical meaning is someone who has a legal right to expect a portion of a person's estate due to a legal relationship with that person
holograph will	a will entirely in the will maker's handwriting without signatures of witnesses
intestate	dying without a will
joint wills	wills that are indentical and cannot be changed without the consent of both will makers
living will	a document that says what medical treatment you desire in the event of a life-threatening illness
maker	someone who prepares and signs a document such as a will, enduring power of attorney, or advance health care directive
mirror wills	wills that are identical but can be changed by one will maker without the consent of the other

probate	the process of having a surrogate court certify that a will is in fact the true last will of the deceased
public trustee	a provincial or territorial government official appointed to look after the affairs of those who have no one else to do so, either during lifetime or after death
springing power of attorney	an enduring power of attorney that comes into force in the future upon the happening of a specified event such as loss of mental capacity
surrogate decision-maker	a person or persons who are responsible for looking after the affairs of an adult who is unable to make his or her own decisions due to incapacity, or after death; see **trustee, executor, guardian, attorney**
testator	a person who makes a will
trustee	a person or persons named in a will or a trust agreement to take charge of the assets described and to invest and manage them for the benefit of the beneficiaries

OTHER TITLES IN THE
SELF-COUNSEL LEGAL SERIES

HAVE YOU MADE YOUR WILL?
WITH DISK

$11.95

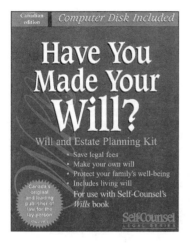

If you die without making a valid will, your family and relatives may have to deal with various legal complications. To avoid this, it is essential to have your affairs in order ahead of time.

By using either the easy-to-understand, pre-printed forms or the disk version of *Have You Made Your Will?* and the information in Self-Counsel Press's *Wills Guide for Canada*, you can make your own will quickly, easily, and legally. The package contains enough forms for two people.

Have You Made Your Will? includes:

- Two blank will forms for each person
- An estate- and business-planning guide
- Two advance medical directives
- A checklist of things that should be done when a death occurs

YOUR PERSONAL DIRECTIVE

Tom Carter, LLB
$14.95

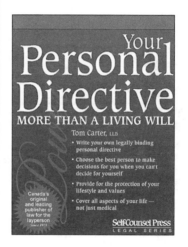

- Write your own legally binding personal directive
- Choose the best person to make decisions for you when you can't decide for yourself
- Provide for the protection of your lifestyle and values
- Includes tear-out forms

Because of the growing population of the elderly, issues relating to living wills are becoming increasingly important. Complex and emotional decisions regarding an individual's health care, finances, and property need to be addressed by the individual and the people who care for him or her.

This straightforward guide examines the importance of a directive; how to prepare your own personal directive; how to choose a decision maker; how to determine your decision maker's powers and responsibilities; and how to store, review, and cancel your directive.

POWER OF ATTORNEY KIT
WITH DISK

M. Stephen Georgas, LLB
$16.95

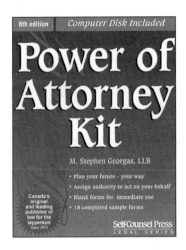

- Plan your future — your way
- Assign authority to act on your behalf

You may be organized and have all your financial papers filed and ready to access, but what if something suddenly happened to you and you became incapacitated? How would your spouse or family access your bank account or take care of your affairs?

Power of attorney is a useful document that gives another person the authority to act on your behalf on certain matters. With the complete information contained in this kit, you can draw up your own power of attorney using the provided set of tear-out, blank forms.

Includes:

- Handing over power for a limited time
- Safety and precautionary measures
- Terminating a power of attorney

ORDER FORM

All prices are subject to change without notice. Books are available in book, department, and stationery stores. If you cannot buy the book through a store, please use this order form. (Please print)

Name _____

Address _____

Charge to ❑ Visa ❑ MasterCard

Account Number _____

Validation Date _____

Expiry Date _____

Signature _____

Shipping and handling will apply.
In Canada, 7% GST will be added.
In Washington, 7.8% sales tax will be added.

Yes, please send me the following:
_____ *Have You Made Your Will? with disk*
_____ *Your Personal Directive*
_____ *Power of Attorney Kit with Disk*

❑ Check here for a free catalogue.

IN THE USA

Self-Counsel Press
1704 N. State Street
Bellingham, WA 98225

IN CANADA

Please send your order to the nearest location:

Self-Counsel Press	Self-Counsel Press
1481 Charlotte Road	4 Bram Court
North Vancouver, BC	Brampton, ON
V7J 1H1	L6W 3R6

Visit our Web site: *www.self-counsel.com*